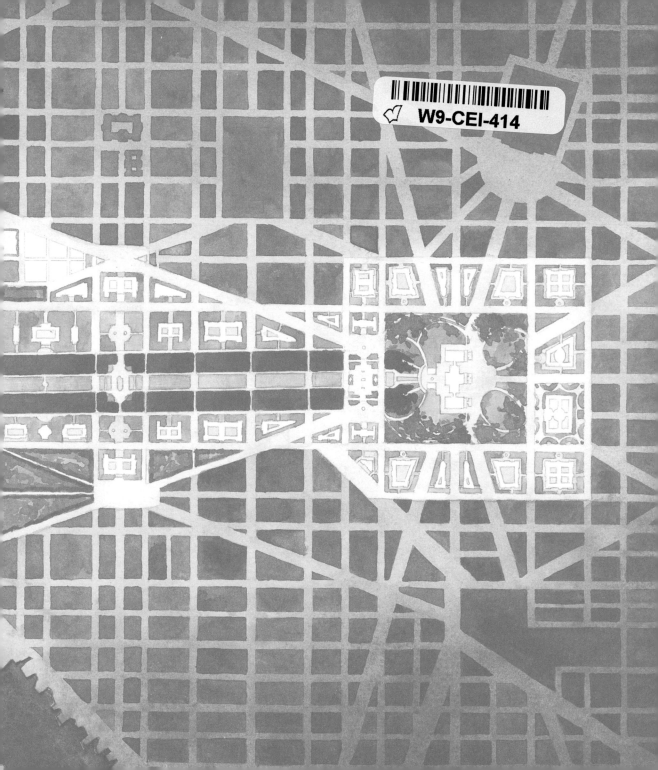

LINCOLN MEMORIAL

LINCOLN MEMORIAL

THE STORY AND DESIGN OF AN AMERICAN MONUMENT

By Jay Sacher

Illustrations by Chad Gowey

CHRONICLE BOOKS

SAN FRANCISCO

Library of Congress Cataloging-in-Publication
Data available.

ISBN: 978-1-4521-2717-0

Manufactured in China.

Design by Kristen Hewitt

10 9 8 7 6 5 4 3 2 1

Chronicle Books LLC
680 Second Street
San Francisco, CA 94107

www.chroniclebooks.com

CONTENTS

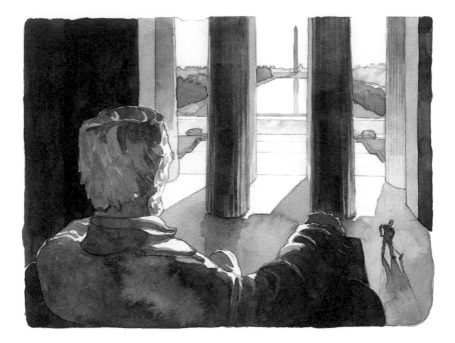

Lincoln's statue overlooks the National Mall

INTRODUCTION

He leads us still. O'er chasms yet unspanned
Our pathway lies; the work is but begun
—Arthur Guiterman

. . .

The Lincoln Memorial sits along the banks of the Potomac River at the western edge of the National Mall in Washington, D.C. It's impressive to behold; built of gleaming Rocky Mountain Yule marble, it stands almost a hundred feet high, its massive columns echoing the stately provenance of the temples of classical antiquity. The seated statue of Lincoln, nineteen feet tall, gazes soberly out toward the Mall, past the shimmering Reflecting Pool, over the Washington Monument, and onward toward Capitol Hill. But then, you probably know this already. It's rare to meet someone who can't instantly recall an image of the Lincoln Memorial.

That it's an international icon there is no doubt, and that it's an elegant and austere feat of architecture in a historic swath of public space is readily evident. What is truly remarkable, however, is that it is perpetually effective. How often does the familiar remain powerful? How often do planned public spaces maintain a relevance to the moment or the figure that they commemorate? History has a way of softening the intended meaning of a space. Even successful monuments, like many of the others on the very same stretch of the Mall as the Lincoln Memorial, can easily become nothing more than a destination—a pretty bit of marble work and a noble use of public funds, but little more than a place to buy a picture postcard.

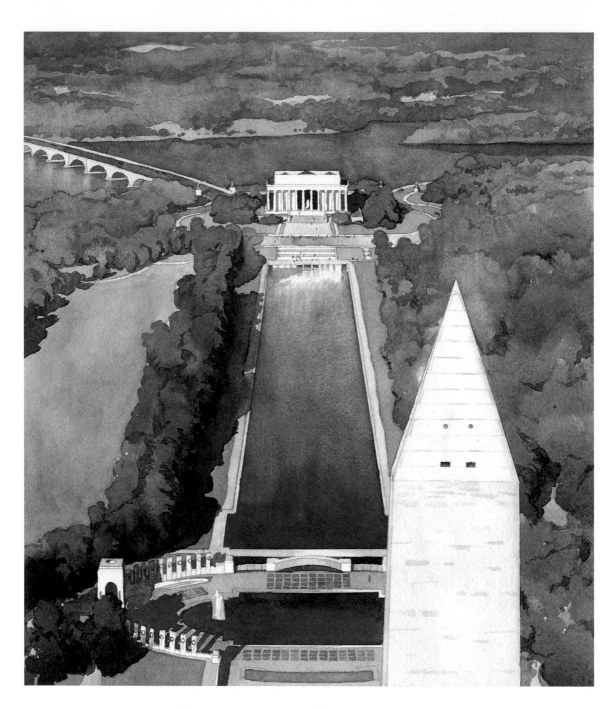

The Lincoln Memorial from the Washington Monument

How then, does the Lincoln Memorial succeed in staying relevant on both a political and an emotional level? By all rights, it shouldn't. Its image is stamped onto the back of pennies and printed on the back of the $5 bill. It's almost as familiar an icon for America as the bald eagle or Uncle Sam. The cartoon visage of Lincoln is used, along with his cherry-tree-chopping colleague, to sell cars and televisions every year on the third Monday in February. And yet, despite its utter ubiquity, the power of the Lincoln Memorial remains as real and solid as the marble it is constructed from.

The riddle of the memorial is akin to the riddle of its subject's life and legacy. Abraham Lincoln was a plain-spoken, intelligent, and forceful man, born at the right time in history, who, through the strength of his will and acuity of his political gamesmanship, and through the bloody veil of years of war, forced a country to accept an idea that it was incapable of accepting on its own. Lincoln's legacy remains a hinge point in American history—before

Lincoln and the Emancipation, and after. And the memorial, while intended to revel in historical significance of the great man and his moment, ushers forth as its *own* hinge in history—instead of looking back, it always looks forward. It begs those who visit it to consider both the courage and the sins that it is built upon. The Lincoln Memorial is where America gathers to challenge itself.

And it has always been so. Its promise is present in the contradictions it showcases. At its dedication ceremony on May 30, 1922, President Warren G. Harding gave a reverential, if somewhat restrained, speech about Lincoln and his accomplishments. Harding posited Lincoln's great struggle as being first and foremost for the preservation of the union. He spoke of an embattled president and a deeply moral man who feared the dissolution of the nation above a desire to see slavery abolished. Harding noted that Lincoln, "hating human slavery as he did," believed that its abolition was inevitable due to "the developing

conscience of the American people." It wasn't that Harding wanted to gloss over the abolishment of slavery as a major accomplishment as much as he and the trustees of the memorial hoped to gently control the symbolism of their new temple. They wanted Lincoln and the memorial placed firmly into history, a static reminder of a great man. The problem is that the very narrative of the memorial's subject is a man who refused to let the machinations of history impede him from his mission. Faced with the imminent collapse of the Union, and aware of the innocent blood that would be spilled in the eff- ort to both destroy the institution of slavery and save the United States of America, Lincoln had no choice but to give history a push.

And the power of the memorial resides in its ceaseless reminder to us that history still requires pushing. Even on the day of its dedication, as President Harding spoke to a crowd of fifty thou- sand people about the evil and greed inherent in the idea of "human chat- tels," the African American onlookers were obliged to stand apart from the rest of the crowd, separated from their fellow citizens by a dirt road and a rope-lined barrier. Dr. Robert Russa Moton, one of the speakers that day, remained behind that rope barrier until he was called up to the steps of the memorial by his white colleagues.

It seems unimaginable today that a monument that has become short- hand for equality and justice, and that was built with the good will of many enlightened individuals, would still be hampered by the prejudices of its time. And yet again, it is only with slow and steady urging that the monument, and the courageous people who have rallied to it, have been able to bend the world's ear to the march of equality. In 1939, some seventeen years after Dr. Moton was snubbed, the memorial again played host to a massive crowd of onlookers. This crowd, however, was racially integrated. They gathered on the mall to hear the African American opera contralto Marian Anderson per- form a selection of arias and popular songs. Earlier that year, Anderson had

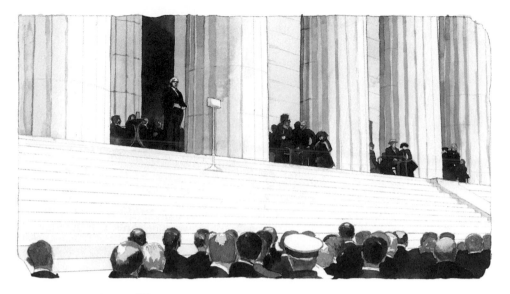

President Harding speaking at the dedication of the memorial

been barred from performing at Washington's Constitution Hall after the venue's owners, the Daughters of the American Revolution, refused to allow a black performer on their stage.

First Lady Eleanor Roosevelt resigned from the DAR in protest. "You had the opportunity to lead in an enlightened way, and it seems to me that your organization has failed," she wrote in a much-publicized letter. With Roosevelt's help, Anderson's concert was rescheduled among the marble monuments of the National Mall. Her husband, in full presidential support of the event, said, "I don't care if she sings from the top of the Washington Monument, as long as she sings." The performance was broadcast over the radio nationwide.

That act of protest in the face of calculated racism set the stage for the lofty symbolic stature that the Lincoln Memorial would assume in the following

decades. From Marian Anderson to Dr. Martin Luther King Jr., and on to Barack Obama, the site has become a symbol of what we *can* accomplish rather than what we *have* accomplished.

In his speech in 1922, Dr. Moton summed up the lasting power of the memorial on that, its first day in existence. He spoke of blacks and whites "working together in the spirit of Abraham Lincoln to establish in fact what his death established in principle—that a nation conceived in liberty and dedicated to the proposition that all men are created equal can endure and prosper and serve mankind."

The "great man" theory of history is rightly out of vogue; we know better than to believe that the wills of heroes and tyrants are the sole driving forces at work in the broad sweep of time. Even Lincoln didn't struggle and succeed on his own; he built on the foresight of those who came before him as well as on the courageous striving of his contemporaries. But a man can be a symbol. And as a symbol of progress, of the collective will of a nation to improve, to strive toward a more true and more complete understanding of equality, Abraham Lincoln is never out of place, out of vogue, or diminished. Standing in front of the memorial on January 18, 2009, President-elect Barack Obama signified Lincoln as the founding father of civil rights, and of his own ascension to the presidency. "And behind me, watching over the union he saved, sits the man who in so many ways made this day possible."

The Lincoln Memorial's history is a rich and storied one. On a physical level, it is entwined with the growth of the city it resides in, and the politics and fashions of the era that produced it. On a spiritual level, it continues to evolve. It is the last great monument of an earlier age, and yet it carries on its columns all the burdens of the twenty-first century—all the ascendant problems and the quirks of history and the vibrant color of pop culture and the force of the personalities that have touched it. Its dynamism is its strength, and its strength is our strength.

THE CITY BEAUTIFUL AND THE BIRTH OF THE AMERICAN MONUMENT

. . .

n July 2, 1864, as the Civil War continued its bloody path across the divided union, President Abraham Lincoln signed legislation authorizing the transformation of the "Old Hall" of the House of Representatives, which had been vacated by the Senate some years before for more spacious quarters, into the National Statuary Hall. Each of the Union's states were invited to "provide and furnish statues, in marble or bronze, not exceeding two in number for each state, of deceased persons who have been citizens thereof, and illustrious for their historic renown or for their distinguished civic or military services such as each State may deem worthy of this national commemoration."

One of Vermont's statues in the National Statuary Hall

In his career, Lincoln certainly signed more important legislation of lasting moral value and historical significance, but there is something telling in the symbolic act of creating a shrine that required each state's intimate involvement in the

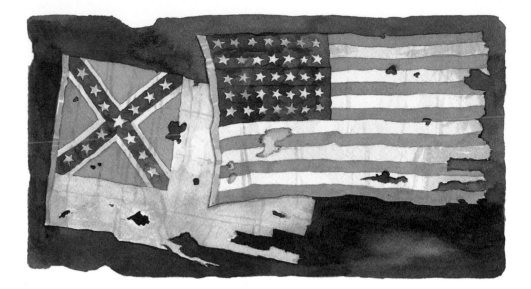

Union and the Confederate flags, 1864

creation of a single whole, especially at a time when the nation was waging a war with itself. It was a sign of things to come, both of the physical reunification of the nation and of the philosophic centralization of the *idea of* America. Ever a youthful country, in the 1860s the United States was a mere infant. Not yet a century old, the stories it was attempting to tell about itself were still fragmented and emerging; the symbology of the national identity was still green and in many ways formless.

Consider that in 1864, Mark Twain was still working as a reporter in the gold-crazy West, his great American novels, including *Huckleberry Finn*, the book from which Ernest Hemingway famously noted all modern "American" literature is birthed, would not be finished until 1883. "The Star Spangled Banner" would not be officially recognized as the country's national anthem until 1931, with various contenders, such as "Hail Columbia," regionally holding their own throughout the

1800s. Even the very names of the states and emerging territories of the nation remained in flux. Arizona was recognized (surprisingly) by the Confederate States of America in 1861 (over such other choices as "Pimeria" and "Gadsonia"), and Nevada was ushered into existence (over the name "Humboldt," which was preferred by the prospectors who called the state their home) by the United States in 1864. And of course, all the many towns and cities in the nation (including a state capital) named Lincoln were yet to be called thus (all except for one: in 1853, Lincoln, then a lawyer in Springfield, Illinois, was hired to help prepare legal documents for surveyors laying out a site in a rural part of his state. The surveyors proceeded to name the town for him in gratitude. Lincoln is said to have genially chided them, observing that he "never knew anything named Lincoln that amounted to much").

As the American "story" began to coalesce in the in the latter half of the nineteenth century, so too did the

government itself shift toward a more centralized identity. Previously, politicians and thinkers spoke of *"these United States"*—as the phrase was written in the Declaration of Independence—echoing the earlier notion of a loose confederation, to *"the* United States," a single body, a Union, rescued and restored from bloodshed and sin by a martyred president. The necessities of the Reconstruction, various economic crises, and the emerging industrialized culture all helped herald in the new, stronger federal government, but it was (and remains) an ongoing ideological battle. As discussed in more detail later, that tug of war over the nature of American government was at the center of the long delay in approving and building a national memorial to Abraham Lincoln, but no matter where individuals assigned their ideological allegiances, it was clear that by the 1870s, a new understanding of American identity was emerging.

Before that decade, civic monuments to national heroes in the United States were not unheard of, but they were

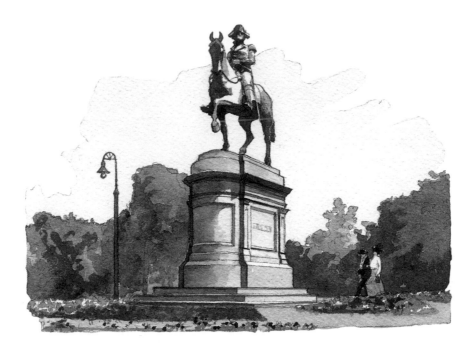

Thomas Ball's bronze statue of George Washington in the Boston Public Garden

rare. There were well-known memorial statues in three major cities—New York, Washington, and Boston—all of George Washington on horseback. Washington was the most popular of subjects, but slowly, a wider pantheon of heroes began to emerge. Clark Mills's statue of Washington in the capitol was dedicated in 1860; by 1914, Washington boasted statues and memorials to Benjamin Franklin, John Witherspoon, Edmund Burke, the Marquis de Lafayette, Nathaniel Greene, General Casimir Pulaski, Brigadier General Thaddeus Kosciuszko, John Paul Jones, and Captain Nathan Hale, among others. New York's Statue of Liberty was dedicated in 1886, and most of that city's major classical monuments were born in the same era and

into the early years of the twentieth century. And so it was in the other major American cities: Thomas Ball's bronze of Washington in Boston's Public Garden was dedicated in 1869, and Philadelphia's statue of Commodore John Barry at Independence Hall was dedicated in 1907.

While the national identity had indeed shifted, there was more at work in this explosion of classical sculpture in the New World. America in the first half of the nineteenth century remained a frontier nation. There were no parallels to the classical tradition of European sculpture and art. The skilled-craftsman carvers of Florence and Rome, so adept at transferring plaster designs to marble, had no equals across the Atlantic. Even the infrastructure for quarrying marble did not exist on the scale that it did in Europe. American artists of the era went to Europe for education, but they often stayed in Italy to work. These early American craftsmen, such as Horatio Greenough and Thomas Crawford, sold their sprightly marble fauns and stern Roman busts for display in the drawing rooms of the New World's elite. Around the midcentury mark, American sculptors also began to flock to Paris to study the more delicate clay work necessary for casting successful bronze sculptures. The pool of talented American ex-pats was growing and developing its own tradition; now something was needed to call them home. The 1864 authorization of the National Statuary Hall provided the perfect proving ground for a growing class of artisans eager for a genuine American voice, one that fit in well with a revived interest in civic monuments, and that would lead directly, across the decades, to the Lincoln Memorial.

Rising concurrently with the increased skill of American-born artisans was a larger idealistic notion about the American city and its architecture, one that coalesced toward the close of the century as a school of thought called the "City Beautiful." The movement was born from, and closely related to, the Beaux Arts architectural style that influenced the American cityscape

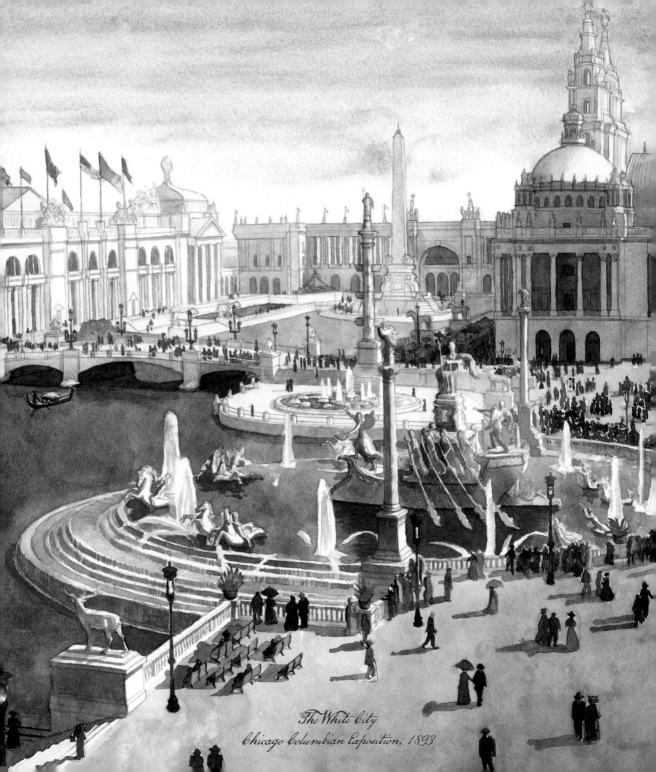

The White City
Chicago Columbian Exposition, 1893

throughout the Gilded Age of the nineteenth century. Simply put, the Beaux Arts style refers to a bold neoclassical approach to architecture that was taught at the *Ecole des Beaux-Arts* in Paris. Its influence in America was both direct (as students returned from Paris to build in America) and indirect as the style caught on throughout the nation. Many now-historic buildings, such as the New York Public Library and Chicago's Union Station, are prime examples of the magnitude and grand ambition of the Beaux Arts style.

The City Beautiful movement married the aesthetic of the Beaux Arts movement to a struggle to better both the visage of the city and the spirit of its inhabitants through compelling architecture; wide, pleasant thoroughfares; and artistically embellished public space and parklands. The stated goal was not to simply make a city more pleasing to the eye, but to enlighten and enrich its residents and to use the newfound wealth of the industrial era to build a better life for all. One of the City Beautiful's major proponents,

Charles Mulford Robinson, considered the movement to be "the latest step in the course of civic evolution. The flowering of great cities into beauty is the sure and ultimate phase of a progressive development." Of particular interest, he noted the power of political and state-sponsored monuments. "For where political life is ardent, the civic consciousness is strong; the impulse toward creative representation is fervent; and state, government, the ideals of parties, are no longer abstractions, but are concrete things to be loved or hated, worked for, and done visible homage to."

The movement's genesis was thanks in a large part to the Chicago architect Daniel Burnham, who along with Fredrick Law Olmstead (the designer of New York's Central Park) created a living example of the City Beautiful for the Chicago Columbian Exposition of 1893. The fairgrounds, known as "the White City" (the buildings' facades were finished with a gleaming white stucco), covered six hundred acres with stunning neoclassical architecture,

designed in concordance with axial pathways and manicured lagoons and canals. Burnham called the fair "the third greatest event in American history," and while such a statement might be the hyperbolic doting of a loving parent, the fair's impact was indeed deep. It was a premier showcase for American exceptionalism and brought the City Beautiful movement to the lips of every municipal planner in the nation, the trickle-down effect of which is evident in almost every major American city today. While Burnham's most ambitious design was a 1906 reworking of the city of Chicago, his work had caught the eyes of planning commissions across the nation. He developed plans for Cleveland and San Francisco, and he became one of the guiding members of Washington D.C.'s McMillan Commission, the Senate committee (named after Senator James McMillan) that was responsible for the creation of Washington's National Mall as we now know it, and the eventual creation of the Lincoln Memorial. Along with Burnham, the McMillan Commission boasted the presence of

such design luminaries as Fredrick Law Olmstead, Charles McKim (whose firm would later design New York's original Penn Station), and sculptor Augustus Saint-Gaudens (whose 1887 work, the *Standing Lincoln*, resides in Chicago's Grant Park). Its mission was to improve upon the original, but never completed, plan for Washington, D.C., that was set forth by Major Charles L'Enfant in 1791, and to raise the city's beauty and standard in general to one befitting a national capital.

The Macmillan plan was published in 1902. Its far-reaching recommendations included moving the site of Union Station, advice on the placement of Federal Buildings, and, most significant, a comprehensive layout for the National Mall into a cohesive and complete parkland, with the proposed Lincoln Memorial as a key feature on its western edge: "By the inclusion of the space between Pennsylvania and New York avenues on the north, and Maryland Avenue and the Potomac River on the south, the new composition becomes a symmetrical, polygonal,

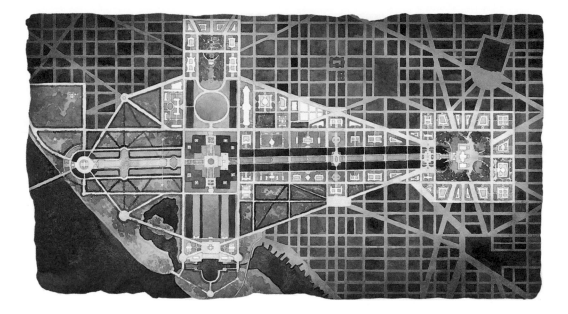

The McMillan Plan, 1902

or kite-shaped, figure bisected from east to west by the axis of the Capitol and from north to south by the White House axis. Regarding the [Washington] Monument as the center, the Capitol as the base, and the White House as the extremity of one arm of a Latin cross, we have at the head of the composition on the banks of the Potomac a memorial site of the greatest possible dignity."

That *dignified site* proposed to honor Lincoln, so clear and evident on paper, turned out to be one of the most controversial aspects of the plan. Political infighting and passionate advocacy for and against the site would embroil the commission members, the Senate, and the city of Washington for the next decade. There remained a long struggle ahead for the Lincoln Memorial.

UNCLE JOE AND THE LONG ROAD TO THE LINCOLN MEMORIAL

. . .

S o long as I live, I'll never let a memorial to Abraham Lincoln be built in that goddamned swamp." So spoke the pugnacious Joe Cannon, "Uncle Joe" to the press and the public, Appropriations Committee chair and Speaker of the House from 1903 to 1911. His vow was uttered to President Theodore Roosevelt's secretary of war, Elihu Root, and it was meant to be the final word on the

"Uncle" Joe Cannon

Potomac Flats, a recently filled-in swath of marshland adjacent to the shores of the Potomac that had been proposed as the site for a memorial to Abraham Lincoln.

Uncle Joe, like Lincoln himself, was a Republican congressman from Illinois. Early in his career, he had met Lincoln (which gave him a sense of purpose on the matter), and he was also one of the most powerful speakers of the House the country has ever known. At that time, the Speaker was also the chairman of the House Rules

Committee. Which meant that Uncle Joe controlled what issues the House could put before the Senate floor—if he was against something, it would be an uphill battle to even get it officially discussed. And at least initially, he was opposed to any memorial being built on the Potomac Flats, and he was certainly opposed to the estimated cost of $2 million. Above all, however, he was opposed to the McMillan Plan and its proposal of, among other beautification projects, a green beltway of monuments, museums, and office buildings that would run from the Capitol Building, crisscrossing along a north-south axis with another parkway that led to the White House.

Over the decades, the McMillan Plan has been largely carried out, although not on as grand a scale as was first proposed. The plan was a source of frustration to Cannon on two fronts. First, as a died-in-the-wool Republican, he was opposed to any grandly expensive government overture as fiscally irresponsible. Second, the

House of Representatives had been sidestepped in the creation of plan's commission, so, from a purely political perspective, it rankled him and his power base to no end. He would spend years attempting to undermine the commission's efforts.

To any longtime Washington resident at the beginning of the twentieth century, it was clear why the Potomac Flats might be deemed inhospitable to a public monument. The flats, originally a marshy tidal basin, had, by the mid-nineteenth century, become a man-made wasteland of mud, dredged silt, farming run-off, and raw sewage. After a flood in 1882 inundated the White House, a plan was put forth to "reclaim" the land, and hopefully, as a *New York Times* article noted at the time, end the yearly appearance of malaria that "compels the residents of Washington to flee from it during the months of heat, and cause well-informed persons all over the country to avoid it during that season as they would a pest house."

The West Potomac Flats, 1890s

By the 1890s, the flats had been filled in to become West Potomac Park, adding almost a mile of land to the city, just adjacent to the Washington Monument. But it was a rough, neglected area with a bad reputation, crossed with weeded-over railroad tracks and peopled by vagrants and gamblers. The leap of imagination from that to the immaculately maintained National Mall it would become was too much for Uncle Joe. If built upon the shores of the muddy river, Cannon said, the memorial itself was certain to "take fever and ague, let alone a living man." Joe Cannon was perhaps the most tenacious obstacle to the construction of the memorial, but he wasn't the first. In 1867, just two years after Lincoln's assassination, an act of Congress had incorporated an association "for the purpose of erecting a monument in the city of Washington, commemorative of the great charter

of emancipation and universal liberty in America." The sculptor Clark Mills, best known for his equestrian statue of Andrew Jackson that stands in front of the White House, drew up plans for a bronze-cast monument to sit on the northeast corner of the capitol grounds. Mills's monument would have featured thirty-six different figures on various tiers, with Lincoln signing the Emancipation Proclamation at its peak. Despite a nationwide fundraising effort, the politics of the Reconstruction era proved too difficult to maneuver, and plans for the monument languished and were eventually cast aside.

In 1901, an old friend and colleague of Lincoln's, Senator Shelby Cullom of Illinois, introduced a bill proposing a monument to Lincoln, and thus began the second wave that eventually led to the construction of the memorial. Years later, as memorial preparations passed from one Senate resolution and committee to another, and as Lincoln's one hundredth birthday approached, Uncle Joe backed an alternative plan to build a memorial near the recently opened Union Station, so that all who visited the city would see the memorial without added expense or travel. It would also have the added benefit of raising local real estate values by demolishing an adjacent Irish slum known as "Swampoodle" that was considered an eyesore and blight on the evolving character of the city. Which result was more important to Cannon is open to speculation.

Meanwhile, an alternative plan was proposed to construct, instead of a static memorial, a great highway in honor of the fallen president that would run from Washington to Gettysburg, some eighty-five miles away. Proponents of "The Lincoln Way" imagined it along the lines of the Appian Way of Italy; it would be a great historic roadway lined with fountains and parkland. It was also seen to be a beacon for the challenges of the coming century— helping to publicize the need for better American roadways (and trump up the burgeoning automobile industry) as well as give honor to Lincoln, his

great speech, and the bloody battle at Gettysburg. Although this plan gained a wide array of supporters and a generous amount of media attention, nothing concrete came of it.

With Cannon's backing, and the Union Station plan verging on becoming a reality, President Theodore Roosevelt (long stymied and rankled by the machinations of Cannon), upon the urging of the American Institute of Architects, instituted an order that blocked any final decision until an expert commission could review it and any other planned public artworks. This Council on Fine Arts was created by Roosevelt's privilege of executive order, thus bypassing Congress, further infuriating Cannon. This being one of Roosevelt's last acts before leaving office, his successor, Howard Taft, promptly disbanded the commission with the hope of working through Congress to achieve the same goal.

Which he did, just as—perhaps not coincidentally—Cannon was stripped of much of his power by his Republican

Shelby Cullum

colleagues in Congress. The end of "Cannonism" forever changed the power that the role of the Speaker had, and effectively ended Cannon's reign, although he wasn't voted out of office until 1912 (and he was back again in 1914). The newly established Council of Fine Arts was soon followed by, finally, a Congressional Lincoln Memorial Commission, formed on February 9, 1911. Taft was the chairman of the seven-person commission, which featured Cannon, Shelby Cullom,

and other bipartisan lawmakers. Although the political wranglings over the memorial were far from over, the establishment of the commission, complete with an allocation of funds for the act, ensured that, eventually, construction would indeed begin and the memorial would become a reality.

Shelby Cullum, Lincoln's old friend, became the resident commissioner of the Lincoln Memorial project, overseeing its final preparations leading up to construction. Cullum died on January 28, 1914, at age eighty-five. Just two weeks later, on February 12, ground was broken on the northeast corner of the Potomac Flats site. After forty-seven years, construction of the memorial was finally under way.

COMPETING DESIGNS

. . .

While it had taken decades to get the memorial's construction officially underway, the choice of its designer was never really a point of contention. There was, in fact a sort of "closed" design competition between two well-respected architects, but all evidence points to the clear fact that Daniel Burnham's Commission of Fine Arts, the newly formed agency that made official recommendations to the Lincoln Memorial Commission, had a distinct favorite architect in mind: Henry Bacon.

Steeped in the Beaux Arts style, almost all of Bacon's professional work was for public monuments and sculptures, first for the celebrated New York firm McKim, Mead & White, and then later on his own. Furthermore, he was well known to Burnham, who had met him during the construction of the White City in Chicago; Bacon had been Charles McKim's personal representative to the fair. In Chicago, Bacon also befriended the sculptor Daniel Chester French. The two's personal friendship blossomed into an incredibly fruitful professional relationship as Bacon began to design many of the architectural elements for French's sculptures. French, too, was a member of the Commission of Fine Arts, and since Bacon had already been tinkering with plans for a memorial since as far back as 1897, he was both professionally and socially a shoo-in.

Still, politics are politics, and Bacon's stewardship of the project, while being steadfastly pushed forward by the guiding hand of the commission, still needed some vetting from other contradictory powers. In 1910, Speaker Cannon, then

also a member of the Lincoln Memorial Commission, was still at work trying to thwart the aims of the Fine Arts Commission. No appointment was assured with Cannon in the mix. When Bacon was brought to Washington, it was impressed upon the senator, in hopes of softening Cannon's bite, that the sculptor was an Illinois native. After Bacon was accepted by the Lincoln commission, Burnham wrote to Bacon, telling Bacon that he was pleased that he had "got near Uncle Joe, [since being] an Illinois boy counts with him."

Henry Bacon

Cannon and his cohorts had one last countermeasure, however. They proposed that alternative designs for other sites be prepared by the architect John Russell Pope to compare against Bacon's Potomac Flats plan. This was a competition in name only. Pope would "prepare designs for a suitable memorial to be located on the Soldiers' Home grounds on the axis of North Capitol Street, and also for a suitable memorial to be located on the high ground on Sixteenth Street, north of Florida Avenue, these two sites seeming the most

Daniel Chester French

promising next to Potomac Park." At this stage, any other site than Potomac Flats for the memorial was almost certainly a political lost cause, but Pope's muscular and creative designs helped raise the overarching quality of the conversation around the nature of the memorial.

Pope's proposal for the Soldiers' Home site is striking in its scope. In his report to the commission, Pope described it as: "On the axis of North Capitol Street, on the crest of the hill 1,000 feet from Michigan Avenue, and approached from it by a court 400 feet wide, is placed a platform 600 feet square. This platform rises on grass terraces to a height above the adjoining trees. The platform has an elevation of 225 feet, or is at a height well above the columns of the Capitol Dome. In the center of this, and slightly raised above the terrace, stands the figure of Lincoln. Around him stand monumental sentinel columns in the form of an arcade 320 feet in diameter and with the entablature and attic measuring 70 feet in height."

John Russell Pope

Pope hoped to use the elevation of the site to compose an almost Olympian monument to Lincoln, his seated statute enshrined in a circular temple that would evoke a lonely vision of a sort of lofty god, held high and singular on a windy hill. Of his designs, Pope stressed that there is "no architectural feature symbolical of governmental or other significance than that of homage as a setting to the figure of the man. The architecture is for this one direct purpose." This singular thematic focus

would stand in striking contrast to Bacon's design, which ideologically attempted to stress the saving of the Union over Lincoln the man, and which had to balance its own loftiness with the competing structures of the National Mall. It's clear that the deck was stacked in Bacon's favor even in this—since designing for a site already attuned to other monuments helped make his designs appear more seamless and intuitive.

Pope's designs for the second site, known as Meridian Hill, were more confined by the smaller space available, but they were no less dramatic. The proposed memorial would divert the flow of Sixteenth Street around a park built on the "crest and slope of the hill." Marble steps 100 feet wide would rise up from the north and south sides of the hill to a height of 250 feet. Atop the hill, the seated statue of Lincoln would be surrounded by a "double rectangle of monumental sentinel columns" each column 8 feet wide and, with their entablatures, 64 feet in height. The drawing that

Pope submitted (executed by his assistant, the now equally well-known architect Otto Eggers) showcase a gleaming temple atop a manicured hill, evoking Grecian temples of antiquity, even down to the rows of fluted trees that call to mind a sunlit Mediterranean hillside.

Bacon had a head start, but he also had a strong vision for the memorial. Early drafts and drawings from 1911 show a fairly consistent approach to the monument and its interaction with the space—a temple in the classic Greek fashion, rectangular and becolumned with a substantial entablature (the ornamented upper base of classic Greek and Roman structures). In the frieze (the ornamented part of the entablature) there were to be carved wreaths as well as the names of the thirty-six states of the Union at the time of Lincoln's assassination. The interior memorial hall would feature the seated Lincoln statue as well as various tablets with the words of his most famous speeches in side chambers. Bacon toyed with a circular

rotunda design, but he abandoned it before making his final pitch to the commission. In his report, above all, Bacon stressed the importance of the site and its relation to the greater pantheon of the city's growing monuments and parkland. "We have at one end of the axis a beautiful building, which is a monument to the United States Government. At the other end of the axis we have the possibility of a memorial to the man who saved that government, and between the two, a monument to its founder."

Bacon's proposed design was elevated by its ability to anchor the western end of the National Mall. The oblong temple to Lincoln would stand in contrast to the totem-esque monument to Washington, but would not compete with it. Ideologically, it would place Lincoln into the greater patriotic assemblage of the National Mall.

Another marked difference between Bacon and Pope's designs was that Bacon envisioned a closed temple rather than an open-air plaza. Wash-

ington's climate was the obvious factor in his decision. Burnham, in his report to the Lincoln Memorial Commission on Bacon's designs, noted that "Especially in winter . . . a monument which, in addition to an imposing exterior, contains a hall or chamber to shelter the statue and other reminders of Lincoln's greatness, will afford conditions of comfort and sentiment conducive to quiet contemplation." Beyond the control of temperature, an indoor monument could also be ideally lit at all times "whatever the weather may be outside."

On February 3, 1912, the Lincoln Memorial Commission officially chose the Potomac Flats location for the proposed memorial and invited both Bacon and Pope to submit designs for the site. This was a conciliatory gesture to Senator Cannon, who, along with his protégé Champ Clark, were the only two members of the Memorial Commission who had voted against the Potomac site. The new designs were reviewed at the close of March. Pope took the dramatic design he had

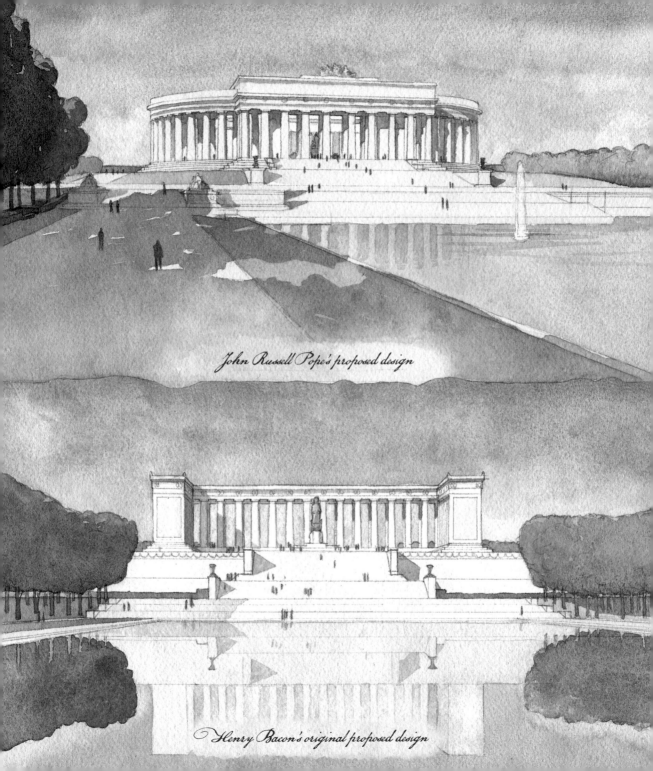

John Russell Pope's proposed design

Henry Bacon's original proposed design

created for the Soldiers' Home site and revised it for the new location. Detailed design sketches show a wide and tall open-air rotunda looking out over the reflecting pool. The proposed rotunda encompassed a diameter of 320 feet (substantially larger than Bacon's finished memorial, which has an exterior dimension of 189 feet by 118 feet). Pope also included other, alternative thematic approaches, including a pyramidal structure that recalled an imposing Mayan temple, although Pope considered these rather fanciful sketches to be conversation starters to "help in the consideration of possibilities in other directions suggested by the discussion of the Memorial Commission."

Bacon submitted three schemes for the site, labeled "A," "B," and "C." "A" most closely resembled his original drawings, but he simplified the exterior and interior arrangements. "This change," wrote Bacon of removing the outer vestibule columns from the design, in his official report to the commission, "not only gives an appearance of greater solidity to the exterior, but gives continuity to the walls of the Memorial Hall." Schemes B and C were open-air colonnade and peri-style, respectively, C featuring a "colossal bronze statue of Lincoln." It's clear from the scant attention that Bacon shows to B and C in his official letter that he preferred scheme A, and so, too, did the Fine Arts Commission, which recommended that Bacon and design A be selected.

Burnham's official letter to the Memorial Commission expresses some frustration in the long process, since both the choice of architect, the site, and the basic design had, more or less, been recommended by the Fine Arts Commission since its inception. "In our report of July 17 1911 we recommended to your Commission the direct selection of an architect to design the Lincoln Memorial. This we did advisedly, because we believe that, while the general scheme of such a monument is of vital importance, the manner in which the monument is executed is equally important." And

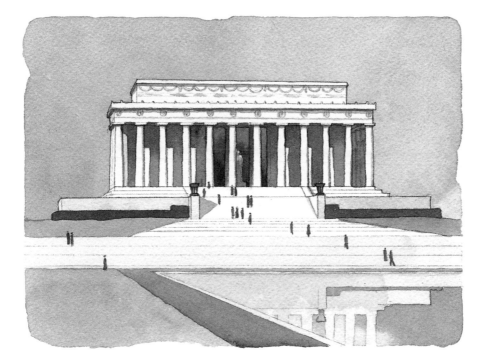

Henry Bacon's final proposed design, Scheme A

it was Burnham's emphatic opinion that Bacon had the "experience, ability and temperament" to carry out the job.

On April 16, the commission approved Henry Bacon and his design scheme A for the memorial. In a scant article that belied the gratuitous political machinations that went on behind the scenes, the *New York Times* reported that Henry Bacon, "a New York architect," had been selected to build the memorial. It was to be a "rectangular marble structure surrounded by Doric columns, each forty feet high, not unlike the Treasury Building here. Congress already has authorized an appropriation of $2,000,000 for it."

BACON AND FRENCH

. . .

ifting past the beltway politics and back-door meetings that led to the memorial's creation, we have at its creative center a remarkable artistic friendship in that of Henry Bacon and the sculptor Daniel Chester French.

Both artistically and by temperament, the two men seemed ideally suited to each other. Bacon, although well respected by other architects, was an insular and modest man, lacking the sort of showman's personality that had so enabled the careers of high-profile architects of the era, such as Daniel Burnham. When writing to his fellow Lincoln Memorial Commission members about Bacon, his friend Frank Millet noted that he "never advertises and has done little commercial work." Born in 1866 in Wateska, Illinois, Bacon began his career as a draftsman and assistant at the celebrated Beaux Arts firm McKim, Mead & White, where he did good work but was stifled under the conflicting personalities of its principal founders. While he mostly assisted McKim, his interactions with the fiercely proud Stanford White, who was both a domineering and a cryptic personality, were strained and difficult. White had a volatile temper and was jealous of his reputation, often taking credit for Bacon's (and other assistants') work. Historians presume that Bacon, who left the firm in 1897, deserves far more credit for much of the work done during his years there—including some of their most famous structures, such as the Robert Gould Shaw Memorial in Boston and the West Point Civil War Monument.

It was while working at McKim, Mead & White that Bacon first met Daniel Chester French. Bacon was McKim's personal representative for the Columbian Exposition

of 1893 in Chicago, where the firm was designing several buildings, including the massive Agricultural Building, which took up ten acres at the fair's southeast corner. French, already a well-established sculptor of monuments, designed four sculptural elements for the building: The Teamster, the Farmer, Indian Corn, and Wheat. His crowning achievement for the exposition, however, was a sixty-five-foot tall statue, *The Republic*, placed in the center of a lagoon at the fair's Court of Honor. Executed in plaster with gold leaf, the exhibition was meant to be a temporary construction. Like many of the fair's structures, the statue was destroyed in a fire in 1896, but a smaller replica now stands in Chicago's Jackson Park. *The Republic*, a female figure holding aloft a lance in one hand and an eagle atop a globe in the other, was at the time the second largest sculpture in the United States, after the Statue of Liberty. French's work for the Columbian Exposition vaulted him in to the forefront of the American statuary field. Despite his success, he remained a thoughtful and

Daniel Chester French's statue, The Republic, at the Columbian Exposition

humble presence, one with keen business sense, certainly, but possessing a sincere and private persona. He preferred his country studio to the bustle of New York. "I spend six months of the year up here," French wrote of Chesterwood, his retreat and summer home in the Berkshires. "New York is—well, New York."

In 1897, French employed Bacon to design and build a sculpting studio

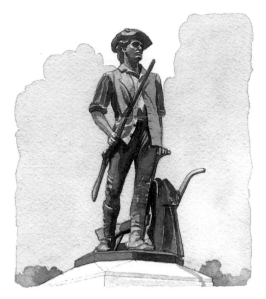

Daniel Chester French's statue, the Minute Man of Concord, Massachusetts

on the grounds of Chesterwood. It was their first of more than fifty collaborative projects that the two would share. In the nineteenth century, the give-and-take relationship between an architect and sculptor was unique in the world of art, and an ideal version of it was embodied in French and Bacon. Years before he met Bacon, a young French had been stung by an

experience "working" with an architect on one of his earliest major commissions, the *Minute Man* of Concord, Massachusetts. For the work, French had entered into a poor contract in which he would be reimbursed only for his expenses and would have no say over the design and construction of the statue's pedestal. Nevertheless, French provided sketches for the base, since the matter of how his statue would be displayed was of no small concern to him. The final pedestal design, by Boston's James Elliot Cabot, was almost identical to French's "original model." Although he publicly acknowledged Cabot as the sole designer of the pedestal, most historians attribute the design to Bacon. While the accreditation didn't seem to rankle the young sculptor too much (working gratis did, however), at the very least, the importance of a strong and genial relationship between architect and sculptor must have been driven home to him. Three years after the statue was unveiled, the glowing reception it had received prompted Ralph Waldo Emerson to write to the

Concord public arts committee and demand that it pay an honorarium to the sculptor. "If I ask an artist to make me a silver bowl," Emerson is reported to have said, "and he gives me one of gold, I cannot refuse to pay him for it if I accept it." French was awarded $1,000.

In Bacon, French found a willing partner and a talent finely attuned to blending architecture and sculpture—both were willing to take a backseat to the other, as well as handle the visionary reins of their projects when called upon to do so. One of their most famous collaborations was a Civil War monument to three fallen brothers, the *Melvin Memorial* in Concord's Sleepy Hollow Cemetery. In reply to a colleague's glowing compliment about the finished monument, French said, "You should give Bacon full credit, too! I shall tell him that you like the result of our joint labors."

For Bacon's part, he often responded in kind, as in: "I have collaborated with a good many sculptors in the design of monuments, Saint-Gaudens among the number, and of them all, I have found the collaboration to be the most congenial when working with Mr. French."

There also seemed to be an inherent trust in the other's abilities. Architects of the era (before computer models and schematics) were required to be keen renderers as well as draftsmen, and one commenter notes the surprising lack of finished sculptural elements in

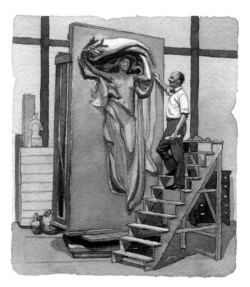

Daniel Chester French working on the Melvin Memorial in his studio

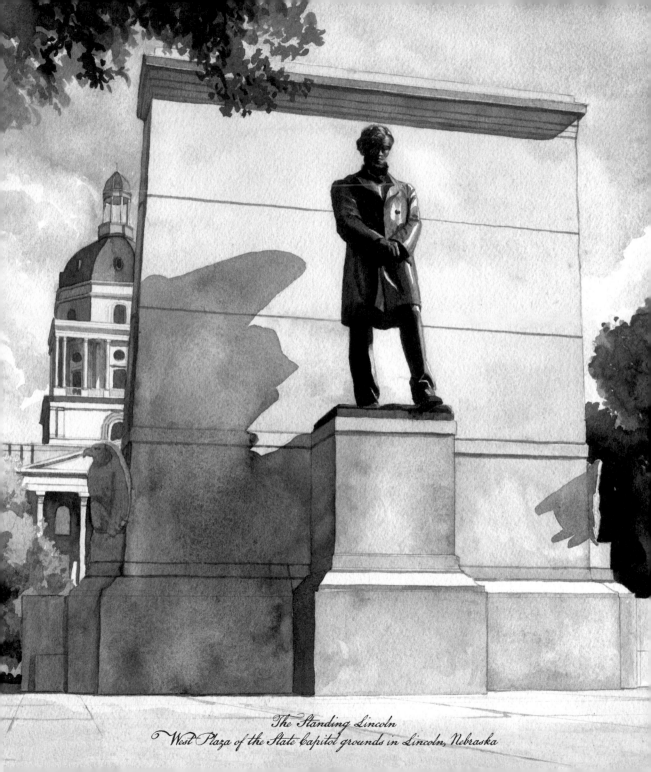

The Standing Lincoln
West Plaza of the State Capitol grounds in Lincoln, Nebraska

Bacon's drawings. "He seems to have studied, or at least drawn, the human figure, and sculpture generally, rather less than might have been expected—especially as during the later part of his career he designed so many monuments—all distinguished by reserve and grace; but that, too, may have been due to full recognition that his usual collaborator, Daniel Chester French, could do that part of the work to his entire satisfaction."

Prior to the Lincoln Memorial, Bacon and French had collaborated on another Lincoln, the *Standing Lincoln* (1909–1912) that graces the West Plaza of the State Capitol grounds in Lincoln, Nebraska. The bronze Lincoln stands solemn and contemplative, his head bowed, his hands clasped, in quite a different attitude than the other most famous "standing Lincoln" statue, in Chicago by Augustus Saint-Gaudens. French's *Lincoln* is less assured and more human than Saint-Gaudens'. French had procured a copy of the famous Volk Life Mask to help render Lincoln's likeness. The mask

was cast by Chicago sculptor Leonard Volk in 1860 for use in a bust of the soon-to-be Republican presidential nominee. The plaster-casting process had taken more than an hour, and when it was removed, "it hurt [Lincoln] a little, as a few hairs of the tender temples pulled out with the plaster and made his eyes water." French would use this historic mask again in sculpting his statue for the monument in Washington. In Nebraska, French "purposely tried to represent Lincoln bearing the burdens and perplexities and problems of the Great War." Bacon's architectural setting is appropriately subdued, befitting the powerful personal nature the statue evokes. Flanked by eagles, Lincoln stands atop a pedestal, with the Gettysburg Address carved into a granite backdrop behind him.

From the beginning of his involvement with the Lincoln Memorial project, Bacon envisioned French as his collaborator. Given the sticky and pernicious political nature of the project, it should be no surprise that there were many

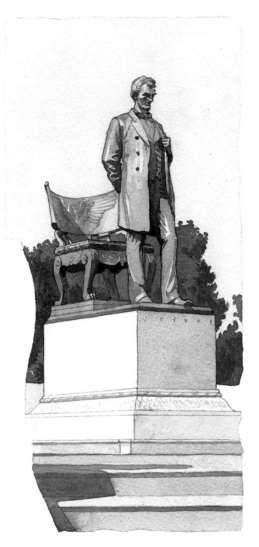

Augustus Saint-Gaudens' Lincoln Statue
Lincoln Park, Chicago

who had other ideas. One of the most popular notions was to simply recast and enlarge Saint-Gaudens' well-liked Chicago *Lincoln* for use in Bacon's memorial. Bacon found this an almost perverse notion, and considered it disrespectful to the artistic legacy of Saint-Gaudens, who had died in 1907. As noted in Bacon's correspondence, when Saint-Gaudens' widow, Augusta, raised the idea to Bacon, he replied to her that "it would be an outrage to modify this important work of Saint-Gaudens, and I believed if he knew of it, he would turn in his grave! Mrs. Saint-Gaudens stated that various people in Washington had expressed the view that the Chicago *Lincoln* should be used in the Memorial, and she asked what she should do about it. I intimated that I had no control over her actions, but that I should certainly oppose any such movement."

Another issue with French's appointment arose since French was a chairman of the Commission of Fine Arts that had recommended Bacon for the job. French did his best to make it

clear that he expected no favoritism, but he knew how it looked. To the commission's secretary, he proclaimed, "I have answered to anyone who intimated that this statue might be awarded to me, that I felt my position on the Commission of Fine Arts would prevent my accepting the commission. I would rather relinquish my claim to this wonderful opportunity than to feel that I had been the cause of injury to a body that I feel to be a powerful good in the community."

Lobbying throughout the arts world helped push Bacon past the whiff of scandal, and with the construction of the monument already well underway (ground had been broken in February 1914), French was officially awarded the commission to sculpt the monument on December 18, 1914. A few weeks later, French resigned from the Fine Arts Commission to devote his full attention to the job at hand.

THE TEMPLE DESIGN AND CONSTRUCTION

. . .

The Lincoln Memorial was built in the early days of the golden age of the American skyscraper (the first steel-frame skyscrapers were built in the 1890s, and such classics as the Empire State Building and the Chrysler Building were constructed in the early 1930s), and although the finished memorial evokes an imposing hand-built temple of the ancients, its construction would not have been possible without the most modern architectural techniques then available.

Of utmost importance, both to the construction of the memorial and to the land-scaping, terraces, and architectural treatments proposed for the site, was the fact that the Potomac Flats was landfill. On average, the landfill had added about 12 feet of depth to the site after it had been dredged from the Potomac River. Borings by the U.S. Army Corps of Engineers revealed layers of sandy soil, "marsh sand," and "rotten rock" (a sort of blanket of crumbled stone above the bedrock), reaching down to about 38 feet below sea level, where the blue gneiss bedrock sat. Anchoring the massive structure of the memorial to that bedrock (on average about 55 feet to 60 feet from the surface) would be necessary, and it would require a prolonged engineering effort.

In March 1914, not long after ground was broken, work on the subfoundation began. The subfoundation is the portion of the structure that is below the original level of the park (there would also be an upper foundation, built above the original level of the site). Once complete, the subfoundation would consist of "122 concrete piers

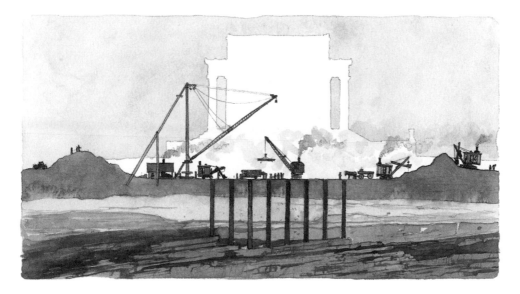

Construction of the foundation

formed in steel cylinders," each from 3 feet to 4 feet in diameter. Depending on how far down the cylinders needed to be buried to anchor into the bedrock, they varied in length from 49 feet to 65 feet. To sink them into place, the construction crews first weighted the cylinders and then "water-jetted [them] to a depth of absolute resistance. The earth was then removed by hand from each cylinder, the bedrock excavated to an additional depth of 2 feet, and the entire space filled with concrete, reinforced with twelve 1-inch square twisted bars set vertically in a circle 6 inches inside each cylinder." At the surface, the entire array of cylinders was then covered with a steel-grilled layer of concrete one foot thick.

The upper foundation, which would support the floor of the memorial (and eventually be hidden by manicured landfill), rises about 45 feet in height,

consisting of concrete pillars joined at the top by "integral" arches (meaning that the pillars and arches are of one piece, not jointed together). The upper foundation was completed by March 1915.

The exterior of the memorial was built with Colorado Yule marble, mined in a quarry in the Rocky Mountains 10,000 feet above sea level. This stone, Bacon's favored marble for the memorial all along, proved contentious, and prior to groundbreaking, it waylaid the project once more because of a heated political battle. The issues with the marble began with its cost. Quarrying it from high in the Colorado Rockies, and then shipping it across the country, especially since it was available in blocks larger than those of eastern quarries, meant the cost threatened to eat too deeply into the $2 million appropriated for the entire project.

As bids came in for the construction, some utilizing the Colorado Yule marble, others with different, cheaper marbles, accusations of favoritism were hurled at the Lincoln Memorial Commission and at Bacon. Senators from Georgia, a major East Coast marble producer, began logging complaints and questioning the quality of the Yule marble. President Woodrow Wilson's Secretary of War, Lindsay Garrison, who had partial jurisdiction over the Memorial Commission, took the charges seriously and called for investigations and tests.

The political battle took on a new character because the Democrats now controlled the White House, bolstered by Southern senators who ideologically might have been opposed to a Lincoln Memorial and at the very least wanted the business of its construction to go to their constituents. The matter was finally settled by a sort of philosophical debate between the commission and Garrison. The commission argued that the choice of marble was an artistic one, and as such they had the authority to decide what was best for the memorial, not businessmen and senators. Bacon's favored construction company, and the Yule marble, were

eventually chosen after six months of infighting.

The marble itself has been consistently praised for its whiteness and quality. Even in modern geological surveys, it is often compared to the illustrious Carrara marble of Italy, which was used in Imperial Roman architecture and in Michelangelo's statue of David. The singular quality of the Colorado Yule marble arises from its even grain and relatively pure content of calcium carbonate, with good selections of the marble containing very few "inclusions" of mica, quartz, and feldspar, which are considered imperfections in high-grade marble. Formed in the Mississippian Period some 340 million years ago, it now rests in beds 200 feet thick in a mountain river valley not far from Aspen, Colorado.

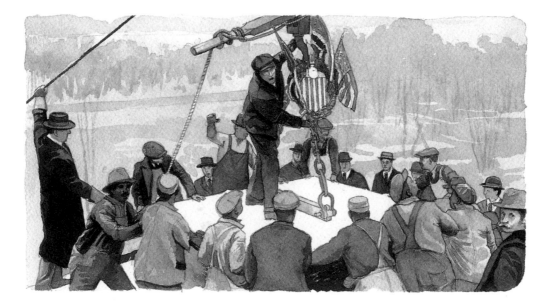

The laying of the cornerstone
February 12, 1915

On Friday, February 12, 1915, the cornerstone, a 17-ton rectangular slab (7 feet by 10 feet wide, 2.9 feet thick) was laid at the northeast corner of the monument. A copper box, placed inside a larger copper box and then encased with slabs of surrounding glass, was placed into a cavity in the center of the stone. Forty items had previously been placed into the box. Along with architectural documents, photographs, maps, newspapers, and magazines, those items included:

- A Bible, with a signature of Abraham Lincoln placed inside its front cover
- The Constitution of the United States of America, amended to May 1, 1913
- A leather-bound Rand McNally Atlas of the World, published in 1914, and
- The first volume of a biography of President Lincoln by Helen Nicolay, signed by Lincoln's only surviving son, Robert Todd Lincoln

Throughout 1916 and 1917, all the exterior and interior marble and limestone work was completed. This includes the thirty-eight Doric columns, each 44 feet high and 7 feet, 5 inches in diameter. Thirty-six of the columns encircle the building; two stand at the entrance to the memorial chamber. The thirty-six columns represent the number of states in the Union at the time of Lincoln's death, although Bacon admitted that the number of columns, at least in his early drafts of the design, was a happy accident and not entirely intentional. Atop the columns rests the entablature, which, in the classic Greek fashion, is divided into first, the architrave (unembellished blocks just above the columns), then the frieze (with its wreaths and thirty-six state names), and then topped with the cornice, the decorated molding that runs along the top of the structure. Above the cornice rests the penthouse, or attic, which is an extension of the exterior walls that rise above the colonnade.

In his official report about the technical aspects of the structure, Bacon remarked that "there are some architectural refinements in the work not

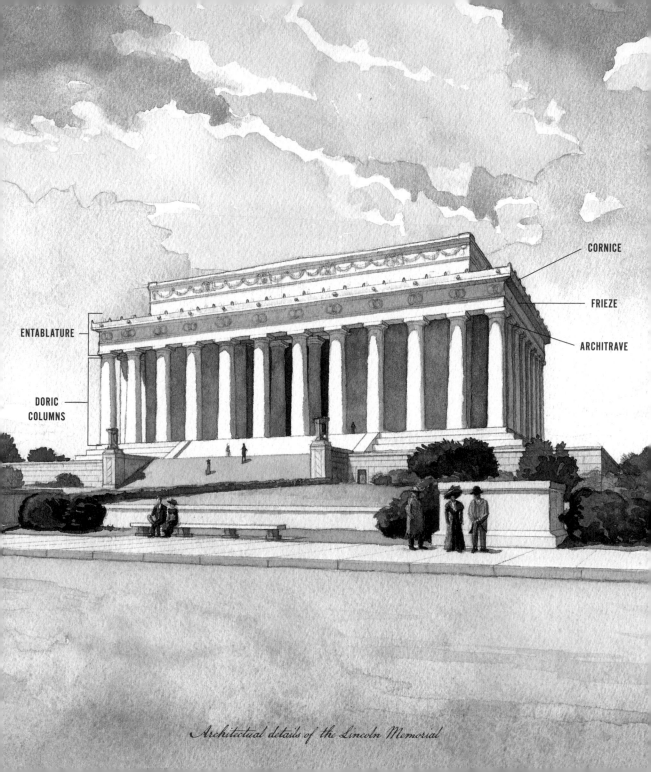

CORNICE

FRIEZE

ARCHITRAVE

ENTABLATURE

DORIC
COLUMNS

Architectural details of the Lincoln Memorial

common in modern buildings." Following the classic Greek approach (as in the Parthenon of Athens), the columns are inclined slightly inward, as is the outer face of the entablature and the exterior walls, only slightly less so in the two latter structures. This reduction of exact symmetry has the effect of actually creating visual symmetry, since the angled walls and columns pull the building together, making it seem less top-heavy and more streamlined. Bacon had also wanted the building's walls to imperceptibly bubble outward, another classic Grecian architectural element, but he was unable to accomplish this with the funds allotted.

Earlier in the design process, Bacon had been forced to abandon his dream of a completely closed interior chamber—he had envisioned glass panels at the entrance, and later, bronze-gilded screens, but these were finally abandoned at the suggestion of the Memorial Commission, and the entryway remained open. His biggest concern wasn't so much comfort on cold winter days as condensation build-up—which did indeed end up affecting the hand-painted murals inside the memorial, which are discussed in more detail in a later chapter.

The interior walls of the memorial are built of Indiana limestone, its floor (a pink Tennessee marble) segmented into three chambers by 50-foot high Ionic columns. The central chamber features the statue (which wouldn't be assembled in place until 1920), the two side chambers' display-wall tablets carved with Lincoln's Second Inaugural Address and his Gettysburg Address, respectively, below stately murals painted by Jules Guerin. The 60-foot high ceilings are designed with bronze girders ornamented with laurel and pine leaves, and interspersed with panels of Alabama marble treated with beeswax to make them translucent. It was Bacon's intention to juxtapose the exterior's bold uniform whiteness with a depth of subtle color within the memorial chamber, accentuated by both sunlight and interior lighting.

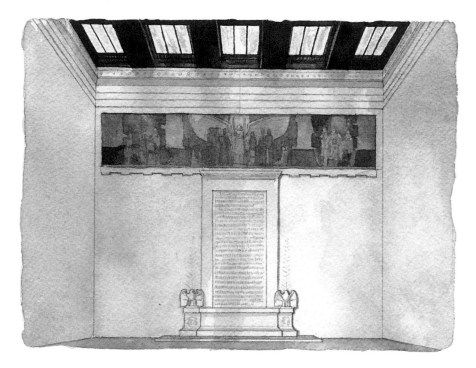

Side chamber inside the Memorial

Although much of the exterior and interior architectural elements of the memorial were complete by 1917, work slowed on the outer landscaping and embellishments as the country entered the First World War—with both workers scarce and transportation of materials more difficult to procure.

One of the unexpected architectural challenges arose regarding the walls and terraced approaches surrounding the monument. The finished monument rests atop a circular hill, which, once the foundations were in place, needed to be created. Throughout 1916, approximately 150,000 cubic

yards of earth were deposited around the exterior edge of the building. Later, more earth would be required to finish the landscaping, some 500,000 cubic yards in total. The terrace walls on either side of the building's front stairway, sort of retaining walls and a decorative element, which surround the approaches to the monument, were conceived along with the entire layout early in the design process. It was originally thought that the exhaustive and costly process in which the building itself was anchored to bedrock would not be necessary for the terrace walls, which would need only simple slab foundation with the expectation that there would be some "settlement" into the loose landfill they were built on. By 1919, however, architect and engineers alike could no longer be assured that the "settlement" would stop. As the slippage continued over the course of the construction, the Lincoln Memorial Commission chairman—former President Taft—wrote to the secretary of the Treasury, informing him that "no prediction

can be made that it will stop with a year, and that while these approaches and the steps and wall which are a part of them will safely stand the present year's settlement, it would not be wise to permit the settlement to go on indefinitely." Although the building itself was in no danger (since it was not structurally connected to the terrace), the new concrete strut and underpinning were proposed and paid for with a new appropriation, and the dedication of the monument was pushed to May 1922 (from an already oft-delayed date of 1920) so that the work could be completed.

The reflecting pool, such an integral element to the entire design of the monument, was always part of the plan for the site, but it was not completed until 1923. The official architectural overview of the site from the 1920s notes that "the pool was contemplated in the park plan of 1901. It was suggested because of the beauty and dignity of the waterways and canals in Versailles, France, and the reflecting basins of the

Taj Mahal in India." The final pool is about 2,027 feet long with a maximum depth of 3 feet. Architecturally, it was seen as a link between the memorial and the Washington Monument to the east. The pool, restored and updated in 2009 to withstand erosion and remove stagnant-water build-up, now immediately borders the World War II Memorial (built in 2004) on its eastern edge.

The exterior ornamentation of the park, from landscaped terraces and stairs to the carvings along the frieze and the buttresses for the main stairs, was completed as the decade came to a close. So, for a time, the stairway that was meant to lead up from the pool to the terraces of the monument stood open-ended at its aperture.

The two buttresses at the foot of the main eastern stairway vault up on each side of the steps, feature totem-like tripods emblazoned with eagles, pinecones, and corncobs created by the Bronx-based Italian master carvers, the Piccirilli family. The steps

rise up along the edge of the 14-foot granite retaining wall to meet the edge of the monument.

Bacon employed Ernest Bairstow to complete the carvings on the entablature. The top of the entablature features garlands interspersed with eagles. Below that are embellished wreaths and the names of the first thirty-six states. Atop the attic are

Buttress at the foot of the main eastern stairway

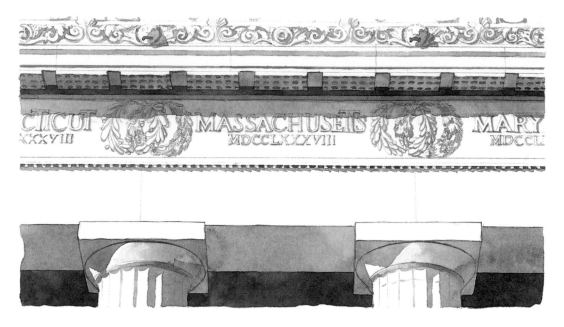

Entablature carvings along the frieze of the building

the remaining states' names, numbering forty-eight at the time of the memorial's dedication. Bairstow would also carve the words for the speech tablets in the interior chamber of the memorial. These exterior carvings were completed throughout 1916 and 1917.

THE STATUE AND THE INTERIOR DECORATIONS

. . .

From his earliest conception of the memorial, it's clear that Bacon had a consistent vision for the elements of the interior chamber. In 1911, two years before he was officially chosen as its architect, Bacon wrote that the memorial should contain "a statue of heroic size expressing [Lincoln's] humane personality and memorials of his two great speeches . . . each with attendant sculpture and painting." And from correspondence detailing the hullaballoo surrounding the plan to use Saint-Gaudens' Lincoln sculpture, it's additionally clear that Bacon always envisioned a seated rather than a standing Lincoln for the centerpiece of the memorial.

Even before French had a signed contract for the commission, he began sketching and conceiving the statue over the spring and early summer of 1915. In May of that year, French wrote to Bacon, "It should interest you that I am making sketch models for the statue of Lincoln. At present I am feeling very much encouraged, but I am suspicious of my first enthusiasms."

The artistic process for French was just as much studious and exhaustive research as it was inspiration. His attention to detail was legendary in the field, and it greatly contributed to the power of his finished pieces. Explaining his process, French wrote, "Be sure that your statue is grand and beautiful and imposing enough and you may (if you are knowing enough) heighten its affect by attending to details. If a sculptor has genius enough to create anything really great the chances are that he will have the ability to enhance its beauty by the proper amount and distribution of detail."

When working on his first major commission, the *Minute Man*, sketches and notes reveal a deep exploration of minor details, such as the firing mechanism of the soldier's rifle, and this deliberate approach to sculpture carried over to his research on the Lincoln statue, despite the fact that he already sculpted a well-received statue of Lincoln a few years before. The Volk Life Mask, with metal rods inserted into the cast of the mask (these were used as reference points for accurate enlargements) was again integral to the process. He also made casts of his own hands to use as the modeling reference for the placement of the statue's hands, which French saw as important to the overall effect of the sculpture.

A 3-foot clay model, a "maquette" used for the sculptor's own personal reference to develop themes and motifs for the final work, was completed by March 1916. The maquette featured ceremonial eagles at the base of statue's throne; these, and most other decorative elements, were removed as

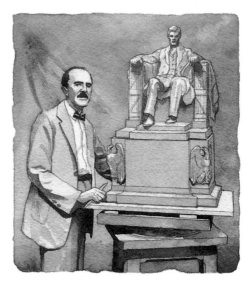

Daniel Chester French with his maquette of the Lincoln statue

the process continued, creating a less flourished, more reverential visage for the statue.

At Chesterwood, French and his assistants spent the summer of 1916 working on a 7-foot clay model that was eventually cast into plaster. Details were refined further and incorporated into a 10-foot model that was completed in the spring of 1917. This second model—the original proposed

height of the statue—was created to display in the recently completed interior chamber of the memorial, so that Bacon and French could judge the statue's effect in its space before the final statue was carved.

All along, French had worried about the proposed height of the statue. When he signed the official contract for the commission in 1915, he asked that the statue's stated height of "twelve feet" be changed to "not less than ten feet," since the heroic scale of the statue would have to be massive to contrast against the mighty size of the memorial, and he didn't want to be locked into a particular size. In March 1917, both sculptor and architect surveyed the model placed inside the memorial. "We found it too small," remarked Bacon. "And after experimenting with enlarged photos of the statue, at varying sizes, it was determined that the statue should be nineteen feet high, and that it would be best to have it cut in white marble." Up until that point, French and Bacon had not yet decided whether the statue

would be in bronze or marble. Estimates from the famed Piccirilli family to execute a 19-foot statue carved from Georgia marble came in at $46,000, well above the 1915 estimate of $18,000 for a 10-foot statue.

In an effort to lessen the cost, and to help ensure an accurate representation of its subject, French proceeded to complete a full-scale model of Lincoln's head (so that the Piccirillis would not have to scale up their marble version from the smaller model). This full-sized model also served one more purpose. French had it taken to Washington. to display in the chamber, as he was concerned about how light would fall on such a massive statue. The tests were inconclusive, and his prescient concerns wouldn't be fully realized until some years later, when all of the memorial's architectural elements were in place and the main entryway was cleared of construction materials, An appropriate lighting scheme—one that took into account the adverse affect of daylight streaming through the chamber's open entryway, was

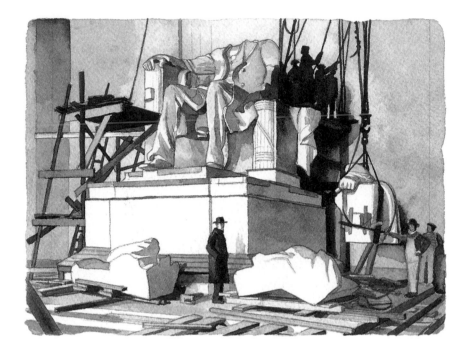

Members of the Piccirilli family assembling the statue, 1919

jury-rigged with the removal of ceiling panels in time for the memorial's dedication in 1922. To French's delight, a more permanent lighting system was installed in 1925.

The final statue, painstakingly carved in twenty-eight different pieces by the Piccirillis, was delivered to the memorial site in the late fall of 1919. In total, it weighed 340,000 pounds. Assembling the statue and last-minute carving took place throughout the winter and the New Year. By the spring, French proclaimed that the statue and pedestal were "an accomplished fact. I have been in Washington several times this spring since the statue was

set in place to put such final touches on the statue as were required and it is now as nearly perfect technically as I can make it."

We have previously discussed how the colored marbles and limestones of the ceilings and floor of the memorial chamber help set it apart from the stately uniformity of the monument's exterior. Along with the massive statue, the chamber is completed by the tablets containing Lincoln's speeches, and the painted murals that accompany them. Hand carved by the same Washington-area artisan, Ernest Bairstow, who carved the states on the outer walls, the tablets containing Lincoln's Gettysburg Address and the Second Inaugural Address are set into the walls and enclosed in embellished stone frames. The Gettysburg tablet resides in the south chamber of the Memorial hall, and the Second Inaugural in the north.

Above each of the speeches hang two massive murals, *Reunion* (above the Gettysburg) and *Emancipation* (above the Inaugural) by the artist Jules Guerin. Professionally, Guerin was a part of the inner circle of the Beaux Arts world, having created rich watercolor renderings for Daniel Burnham when he was proposing the Columbian Exposition. He had done similar work for both Charles McKim for the McMillan Commission and Henry Bacon for his competition materials for the Lincoln Memorial. Though most commonly referred to as the "murals," the paintings on the walls of the memorial are actually oil on canvas, each on scrolls 60 feet wide and 12 feet high. They are the most ideologically emphatic aspects of the memorial in that they are the closest any feature comes to explicitly evoking the specter of slavery. Even this, however, is approached in a more allegorical manner. In Emancipation, on the south wall, the central image references the end of slavery (from the official description: "The Angel of Truth is giving Freedom and Liberty to the Slave. The shackles of bondage

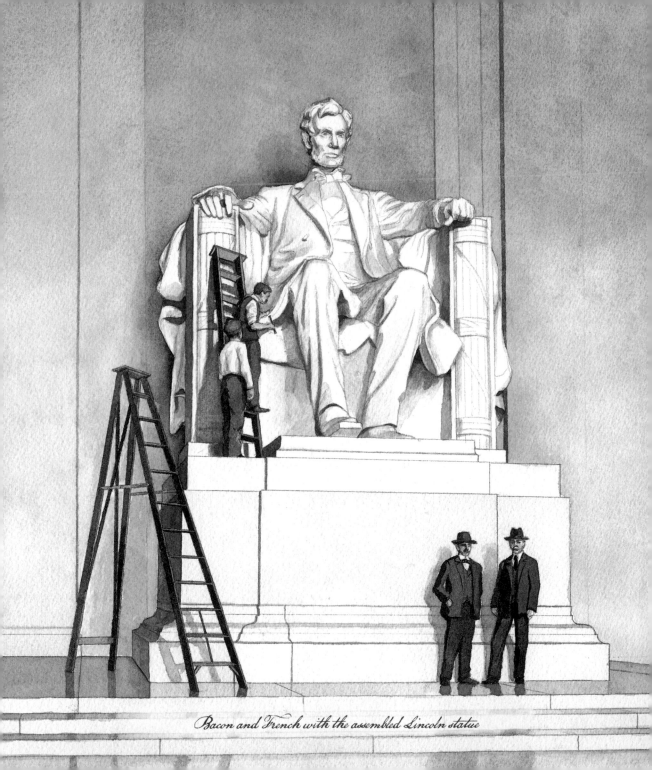

Bacon and French with the assembled Lincoln statue

are falling from the arms and feet.") with the right and left groups making allegorical references to justice and immortality. Above the Second Inaugural tablet, Guerin's allegory shifts to the restoration of the Union. Here, the Angel of Truth joins the hands of the North and the South, bolstered by the themes of fraternity (on the left-hand image group) and charity (on the right).

Despite the fact that a 1922 survey by the Archeological Society of Washington labeled the paints Guerin used as "absolutely waterproof" (because the paint was mixed with "white wax and kerosene," in the fashion of ancient Egyptian murals), one of Bacon's early fears about an open-air building—that of condensation build-up—did adversely affect them. Over the decades, Guerin's colors faded disastrously, but a comprehensive restoration in the 1990s revived the murals' original vibrancy.

The final artistic embellishment—the hand-carved inscription—rests on the wall above the head of the Lincoln statue. It reads:

IN THIS TEMPLE
AS IN THE HEARTS OF THE PEOPLE
FOR WHOM HE SAVED THE UNION
THE MEMORY OF ABRAHAM LINCOLN
IS ENSHRINED FOREVER

In his book *The Lincoln Memorial and American Life*, Christopher A. Thomas notes that, with its intentionally inclusive (but somewhat vague) language, the inscription "is a succinct expression of the memorial's dedication to the idea of reunion." Above all, the memorial's founders hoped to direct the symbolism of the memorial toward one that focused on the restoration of the Union, rather than on emancipation. The larger issues of justice and civil rights that now instantly spring to mind when we think of the memorial were perhaps not an unhoped-for consequence, but at the very least, it was left to those "people" of the Union to supply their own passions to their reverence for Lincoln's memory.

THE DEDICATION

. . .

he Dedication ceremony for the Lincoln Memorial, held on May 30, 1922, which was attended by some 35,000 to 50,000 people and broadcast to many more millions over the national airwaves, remains a lesson in the shocking contrast between the ideals of a nation and its actual practices. On the one hand, there was sincere and necessary celebration on that day. Decades of hard work, artistic endeavor, and engineering reached their culmination in service to a memorial befitting a national legend. Surviving veterans of The War Between the

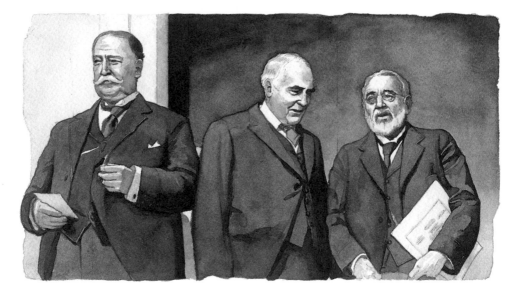

Former President Taft, President Harding, and Robert Todd Lincoln at the dedication

States were in attendance; the fraternal organization the Grand Army of The Republic (comprised of Union veterans) presented their colors. Lincoln's only surviving son, seventy-eight-year-old Robert Todd Lincoln, was in attendance (his last public appearance). The great work, one that would end up having such a powerful symbolic effect in the emerging era, was finally finished, gleaming in the spring afternoon.

On the other hand, there was the stark and undeniable fact of racism that shadowed the entire event. It was both overt, as seen in the segregated audience, with blacks not only roped off to the side across a dirt track—but their presence not even considered in the official seating plans for the ceremony. And it was subtle, as in the curious tone of the official speeches, which stressed Lincoln as the savior of the Union over his role as the "Great Emancipator." A contemporary reader of the speeches presented that day will find it difficult not to moralize. In his remarks, President Harding, as if trying to dispel even the rumor of Lincoln

as a symbol of racial equality, stated that "the supreme chapter in history is not emancipation," but instead "maintained union and nationality." To drive home his point, Harding went on to quote from Lincoln's first Inaugural Address, in which he assured the Southern states that he had no wish to outlaw slavery. Even if all in the audience understood the subtlety of the position Lincoln was in when he spoke those words, and even if all in the audience understood the subtlety of the point Harding hoped to make (that without the restoration of the Union there could have been no hope for an end to slavery), attempting to distance Lincoln from emancipation so drastically in such a public forum remains an astounding subterfuge.

But this was an era in which lynching of African Americans remained commonplace. And the National Mall that the black spectators arrived at to view the dedication was one policed by a mostly southern Army Corps that was poised to make the scene uglier, bandying racial slurs and rough

language. The state of Washington, D.C.'s race relations in the first decades of the twentieth century was astoundingly poor. In a scathing 1906 speech to the United Women's Club of Washington, D.C., longtime resident and early civil rights pioneer Mary Church Terrell lamented, "As a colored woman I may walk from the Capitol to the White House, ravenously hungry and abundantly supplied with money with which to purchase a meal, without finding a single restaurant in which I would be permitted to take a morsel of food, if it was patronized by white people, unless I were willing to sit behind a screen. As a colored woman I cannot visit the tomb of the Father of this country, which owes its very existence to the love of freedom in the human heart and which stands for equal opportunity to all, without being forced to sit in the Jim Crow section of an electric car." Washington was indeed a divided city.

In the speech from the sole black speaker that day, Dr. Robert Russa Moton of the Tuskegee Institute attempted to reclaim Lincoln's spiritual power, and in a sort of preamble to the great purposes the memorial would be put to in the coming years, Moton hoped to shed light on the present struggles for racial equality. His bite, however, was sharply curtailed— the memorial commission harshly censored his speech before the event. In the original draft, Moton expresses dismay at the shocking inequality in his country. "My fellow citizens, in the great name that we honor here today, I say unto you that this memorial which we erect in token of our veneration is but a hollow mockery, a symbol of hypocrisy, unless we together can make real in our national life, in every state and in every section, the things for which he died."

The edited version that Moton actually read maintained some of the sentiment but none of the urgency: "As we gather on this consecrated spot, his spirit must rejoice that sectional rancours and racial antagonisms are softening more and more into mutual understanding and effective cooperation."

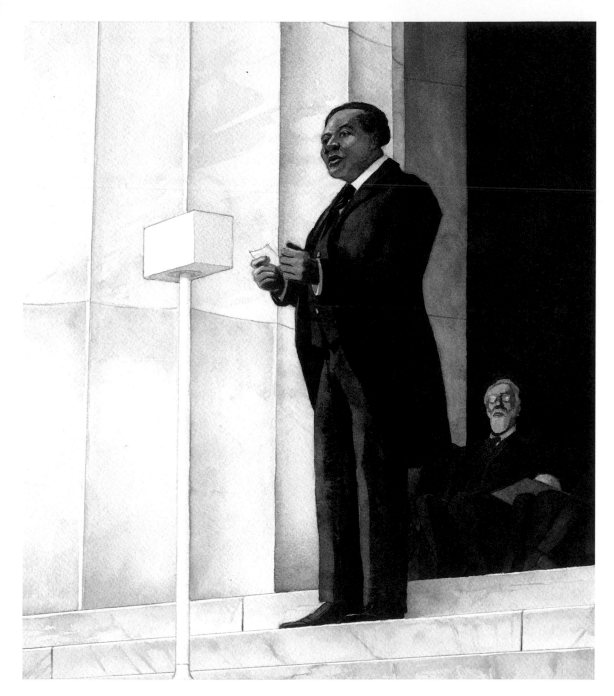

Doctor Robert Russa Moton delivering his address at the dedication ceremony

It is important to note that however unintentionally (or intentionally) shameful some of the aspects of the dedication were, with the construction of the Lincoln Memorial a stage of international importance had been set. What Lincoln had ushered into motion could *not* be undone, and it would not become inert. In Edwin Markham's dedication poem for the memorial, there is a vision of Lincoln as force of moral will. "One fire was on his spirit, one resolve—To send the keen ax to the root of wrong." The story of the memorial since its founding has been one of resolute citizens hearkening to that fiery spirit to complete the work its progenitor had begun.

In 2009, both the bicentennial of Lincoln's birth and exactly four score and seven years from the date of the original opening ceremony, the Lincoln Memorial was rededicated. It followed a similar schedule of events as the original dedication—a poem, the presenting of colors, and various speakers—but of course, as a *New Yorker* article some days before the event noted, "The look and the emphasis of the occasion will have changed—measurably, for certain; astoundingly, perhaps—in the fourscore and seven years since 1922." And changed it was—in the racial make-up of the speakers, the tenor of their words, and the view presented of Lincoln. It was a symbolic effort, publicly acknowledged even in promotional materials, to remove the taint of racism that the original event had carried.

MARIAN ANDERSON AND THE MEMORIAL'S NEW ROLE

. . .

There seemed to be people as far as the eye could see," wrote the opera singer Marian Anderson in her 1956 autobiography. "The crowd stretched in a great semicircle from the Lincoln Memorial around the reflecting pool on to the shaft of the Washington Monument. I had a feeling that a great wave of good will poured out from these people, almost engulfing me." It was Easter Sunday, April 9, 1939, and Marian Anderson opened her famed concert on the steps of the memorial with the patriotic song "My Country 'Tis of Thee" to a crowd of 75,000 people.

It had been a galvanizing collection of months for Anderson and her supporters, one that had mixed commerce, intolerance, and courage to produce an event whose power would resonate through the decades. Anderson, a much-lauded contralto, had seen her fame spread over the second half of the 1930s, first in Europe and then in United States, where she gave about seventy recitals a year. She had developed a long-standing association with Howard University (a pre-integration historically black college in Washington, D.C.) and its Lyceum series of concerts and cultural events. Her fame had increased such that by 1939, after a successful tour of Europe, her draw for a proposed Easter Sunday Lyceum concert had outgrown the traditional venues open to her in Washington. Charles Cohen, the head of the Lyceum series, wrote to the director of the 4,000-seat Constitution Hall, hoping that the Daughters of the American Revolution, the hall's owners, would set aside their "whites-only" rule for the sake of such a prestigious performer. His many diplomatic requests all resulted in unyielding "noes" from the DAR.

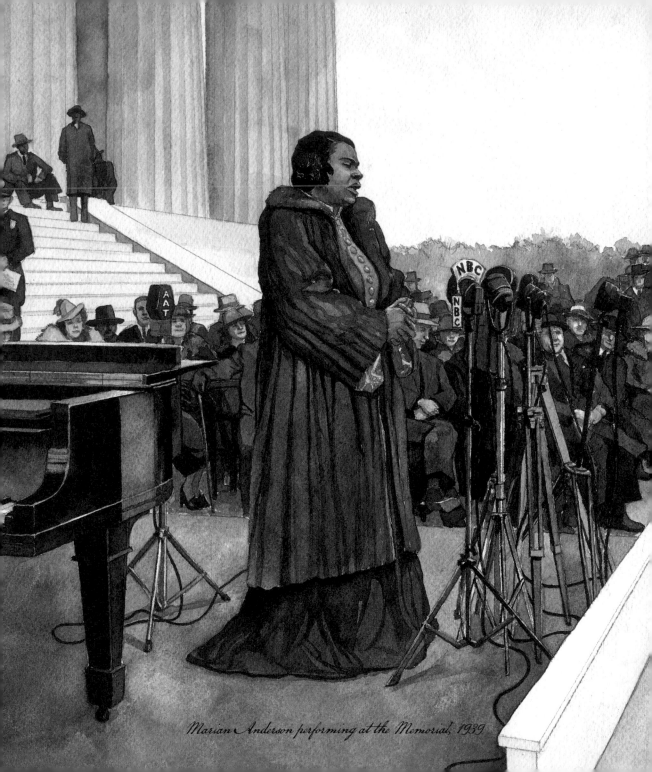

Marian Anderson performing at the Memorial, 1939

On January 12, the *Washington Times-Herald* published a scathing opinion piece on the situation. Constitution Hall, it noted, "stands almost in the shadow of the Lincoln Memorial, but the Great Emancipator's sentiments . . . are not shared by the Daughters." It called the DAR's actions "ridiculous in the eyes of all cultured people and [a] comfort to the Fuhrer Hitler." From lobbyists and the press came more pressure, press coverage, and continued defiance from the DAR (or in the face of defiance, it simply ignored the situation, the president of the organization having conveniently left Washington that winter).

The First Lady's resignation from the DAR, and her announcement of it in her nationally syndicated column, "My Day," followed in late February. This action proved to the be the catalyst that helped Anderson, as one newspaper columnist put it, "transition from mortality to immortality. She is now more than Marian Anderson, the singer. She is Marian Anderson, a beauteous symbol." With the nation on the brink of war and the specter of fascism on the rise, Anderson's snub, and the racial plight it helped showcase, became a point of international concern to many Americans. How could the nation rally against the fascist intolerance and injustices in Europe when its own population was so segmented and abused?

With the Roosevelt Administration's full support, the NAACP, with the blessing of Secretary of the Interior Harold Ickes, arranged for the Easter concert to be held at the Lincoln Memorial. Her audience that day included members of the Supreme Court, Congress, and Roosevelt's cabinet, as well radio listeners nationwide. As the crowd roared their applause after the conclusion of her set, a visibly moved Anderson said, "I am overwhelmed. I just can't talk. I can't tell you what you have done for me today. I thank you from the bottom of my heart again and again." In that moment. the Lincoln Memorial became a national stage—if not *the* national stage—for issues of race relations and social justice.

1963

. . .

nderson's concert showcased the symbolic power of the monument—its presence on the national mall seemed, almost inherently, to bring out the best in people. The memorial as national stage was charged with positivity—and, as the country would learn in the decades to come—with the televised war in Vietnam and the racial strife of the sixties—violence and bigotry do not play on well on camera. The symbolism of its message, and the amplification provided by its geographic and political location, insured that Anderson would not be the last brave soul to stand upon its steps in the name of a cause greater than herself.

Just two years after Anderson's concert, in 1941, the pioneering civil rights organizer A. Philip Randolph began planning a massive "Negro March on Washington" to protest the exclusion of blacks in the growing industrial boom that resulted from the lead up to the inevitable war in Europe (Pearl Harbor would be attacked in December 1941). Denied jobs on the home front, African Americans were also given second-class status in the

A. Phillip Randolph

armed forces, segregated and restricted in combat.

Randolph envisioned 100,000 blacks from across the nation, "sincere in their desire to have justice," marching under the slogan "WE LOYAL NEGRO AMERICAN CITIZENS DEMAND THE RIGHT TO WORK AND FIGHT FOR OUR COUNTRY." With a date set for July 1, and a clear ideological goal—the simple right of American citizens to defend their country to the fullest devotion—one that seemed achievable even given the ingrained racism of the era, Randolph had the attention of reformers across the country. Moreover, he had the attention of the White House. The march's terminus was to be the "famous Lincoln Memorial, where Marian Anderson sang at the feet of the Great Emancipator."

With the memorial at its centerpiece, the march was poised to bring focus to the issue of racial equality in a way that could not be ignored. In January of that year, Roosevelt had given his famous "Four Freedoms" State of the Union Address, in which he passionately argued that all citizens of the world should possess freedom of speech, freedom of worship, freedom from want, and freedom from fear. It was the third of these, "freedom from want," that carried the weight of Randolph's argument. Here were loyal American citizens, desiring only to provide for their families and support their country—how could the nation deny their simple request?

The Roosevelt Administration had been more tolerant of political protests and rallies than many of its predecessors, but for better or ill, it saw calamity in the Negro March on Washington. With war looming (Germany invaded the Soviet Union in June of that year), and with the country still deeply entrenched in its tradition of intolerance, Roosevelt feared the inflammatory potential of the event and negotiated terms with the march's leaders, hoping to get them to cancel it. The result was Executive Order 8802,

signed by the president on June 25, 1941. This was the first equal-opportunity legislation in the nation. As the *New York Times* reported, the order, aimed directly at the defense industry, instructed "official agencies to play their part in eliminating discrimination against Negroes and members of other minority groups and establishing a fair employment practice in the Office of Production Management." The press did not mention the connection between the order and the cancelation of the march.

Although the march didn't happen, it was clear to both the organizers and those that thwarted it that the symbolic power of the Lincoln Memorial had only grown stronger since 1922. It also provided a deep lesson about the power of protest in guiding public policy. Politicians and public sentiment might be willing to accept changes, but they often need a push in the right direction—with the memorial as a symbolic focal point, that push could now have international resonance.

The March on Washington for Jobs and Freedom, held on August 28, 1963, is undoubtedly the most famous protest in American history. Images and speeches from that day are forever cemented in the public consciousness, and its significance is now permanently entwined with the history of the Lincoln Memorial. The march did not spring, Athena-like, fully formed, from one man or one movement.

As we see, it stood on the shoulders of past efforts (both those documented in this book and many more throughout the 1940s and '50s) and on a powerful convergence of events, coalitions, and political actions, as well as the rising tide of civil rights protests in the South and in the North throughout the era. The successful organization of the march required six major civil rights figures working in tandem, the "Big Six" as they were known: A. Philip Randolph, the organizer of the Negro March on Washington; organizer Bayard Rustin; NAACP head Roy Wilkins; SNCC president John Lewis;

"The Big Six," Civil Rights Leaders: A. Philip Randolph, Bayard Rustin Roy Wilkins, John Lewis, James Farmer, and Martin Luther King, Jr.

James Farmer head of the Congress of Racial Equality; and Martin Luther King, Jr., who had by that time been dubbed the "the number one leader of 16 million Negroes."

It also had an initially grudging, but ultimately willing, ally in the Kennedy Administration. Although wary at first of the dangers and potential backlash of such a massive event, President John F. Kennedy met with the organizers in June 1963, after he announced his plan to send a civil rights bill through Congress (the Civil Rights Act, signed by Lyndon Johnson in 1964). Once it became clear to Kennedy that the march would occur with or without his support, and seeing the political advantage of the march

John Lewis speaking at the March on Washington for Jobs and Freedom, 1963

image of unity." The route of the march was to be from the Washington Monument to the steps of the Lincoln Memorial, where the official speeches and programs would commence. Celebrities such as Harry Belafonte, James Garner, Charlton Heston, and Diahann Carroll were on hand to show support. Starting at 10 a.m., an informal musical program began. The performers were Peter, Paul and Mary; Joan Baez; Odetta; and Bob Dylan, who sang "Only a Pawn in Their Game," a song about civil rights activist Medgar Evers, who had been murdered just a few months earlier.

to bolster his proposed bill (balancing the fear of potential riots and tensions within the city) the administration gave a level of support and logistical planning that was unprecedented at the time.

In the end, somewhere around 300,000 people peacefully descended on the National Mall that day, in what historian Lucy Barber called "an indelible

Fears of violence or unrest were happily unrealized. The numerous first aid stations established throughout the Mall area reported no serious incidents, mostly treating cases of dehydration and fatigue. Participants in the day's events recall the overwhelming courtesy of their fellow marchers throughout the day. The formal program began, broadcast live across the nation and Europe on radio and television, around 1:30 p.m. Between

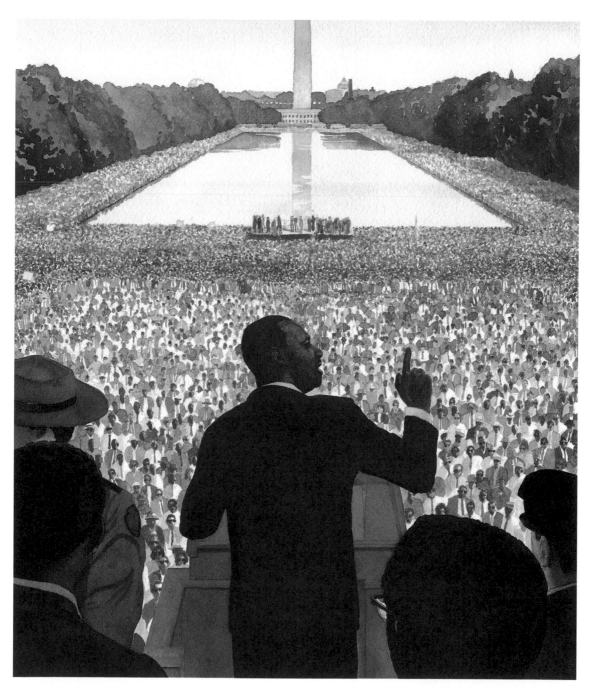

Martin Luther King, Jr. delivering the "I Have a Dream" speech to over 250,000 civil rights supporters August 28, 1963

prayers and invocations, ten speakers took the stage, the most iconic being John Lewis (one of the original Freedom Riders, who had challenged resistance to desegregation in the South) and Martin Luther King, Jr.

Lewis' powerful speech called for action on both a political and personal level. "We will not stop," he assured the crowd. "If we do not get meaningful legislation out of this Congress, the time will come when we will not confine our marching to Washington. We will march through the South, through the streets of Jackson, through the streets of Danville, through the streets of Cambridge, through the streets of Birmingham. But we will march with the spirit of love and with the spirit of dignity that we have shown here today."

At 3:30 p.m., King took the podium and made what was to become one of the most famous speeches in American history. He spoke not from the prepared notes he had worked so studiously over the evening before, but from memory. Returning to and reworking words from previous speeches he had given all throughout that pivotal summer, he refined them for this occasion. Thus was born the "I Have a Dream" speech. Known today to so many millions of people, his words were destined to become as resonant as those of the Gettysburg Address carved on the Memorial wall a stone's throw from where he was standing.

As did the other speakers that day, King tied the current struggle to the history of America. The peaceful battle for civil rights was part of the continuing evolution of a country devoted from its inception to the idea of personal liberty. But King married these concepts to an almost mythical language of destiny and inspiration, in a way that no one had done before—weaving a great and impassioned gospel for an evolving nation.

THE LEGACY OF PROTEST AND POLITICS

. . .

ince 1963, many protests and political movements have flocked to the Memorial with hopes of achieving the iconic stature of what remains the monument's most famous moment. But, especially as the sixties wore on and both the nature of political protest and its goals began to change, and with government's response changing as well, their results have been mixed. The broad political and ideological base and impressive public relations outreach that had allowed the 1963 march to garner international attention was difficult to replicate. And the iconic power of the march was further cemented in the years following it by a series of stark events, including the assassination of President Kennedy a few months later and that of King in 1968. In essence, almost all political acts at the memorial now are in some ways a "response" to the Jobs and Freedom March. In 1983, a twentieth-anniversary march was held, as was another, in 2003—both with large impassioned turnouts but significantly less media coverage. But in the same way that the historic power of something new at the time such as, say, the Beatles playing Shea Stadium, can never be matched by any modern reiteration of a now-familiar model, that fact doesn't make concerts that came after any less moving or powerful. The year of the march at which King made his famous speech,1963, was simply a time when the national gaze was fixed almost exclusively toward one single moment—something that is almost impossible in our more splintered and media-saturated society.

Riots shook the city of Washington in 1968, echoing the national disharmony that rocked the nation. In spring of both 1970 and 1971, student organizations occupied

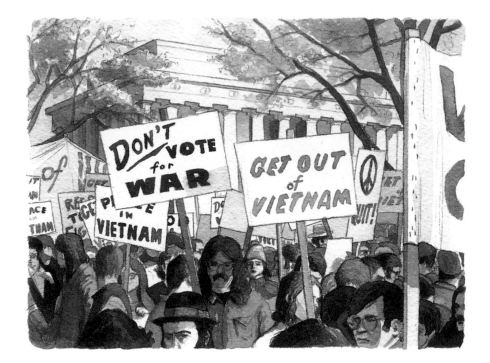

Protest on the National Mall, 1970

the National Mall in protest of the Vietnam War. These "Spring Offensives" as they were known, were largely a loose collective of protests and organizations with divergent goals, but all were in agreement that the war must stop. On an evening in May 1970, the protestors camping out at the memorial were welcomed, in

what remains one of the most bizarre moments in American presidential history, by an unexpected guest, President Richard Nixon.

Several days before, four student protestors had been killed by police on the campus of Kent State University in Ohio. The protestors in Washington

focused their anguish over Kent State on the federal government in Washington and its unpopular leader, who had recently ordered the invasion of Cambodia. By all accounts, Nixon, in the pre-dawn hours of May 9, 1970, was suffering an emotional crisis. At 1 a.m., he called reporter Nancy Dickerson to complain about coverage of a recent press conference. His informal greeting ("This is Dick") left Dickerson confused at first as to whom she was talking. By Dickerson's account, it was a disjointed and rambling conversation. "That man had not been drinking," she later recalled, "but I'd feel better if he had been."

President Nixon in the Lincoln Room of the White House

A few hours after the call, a sleepless Nixon was blasting a Rachmaninoff record in the Lincoln Sitting Room (a favorite room of his, on the second floor of the White House). The music awoke Nixon's valet, Manolo Sanchez, who found the president staring out in the direction of the protestor encampment. Nixon informed Sanchez that he should get dressed as they were going to go down to the Lincoln Memorial.

The late-night visit included Nixon, his valet, his doctor, and a team of Secret Service agents. As Nixon and Sanchez strolled through the memorial, some of the protestors recognized their visitor and walked up to greet him. It is here where Nixon's account of the evening (documented in his recorded memos and conversations after the incident) diverges greatly from that of the students he spoke

with. Nixon's memory of the event was of a courteous encounter between youth and wisdom, with both sides agreeing to disagree in the face of difficult circumstances. He hoped, he said, that their hatred of the war would not become a hatred of America. "I said that I know probably most of you think I'm an SOB," Nixon said, "but I want you to know that I understand just how you feel."

And while the students' memories were of a courteous exchange as well, they recall one of a decidedly more off-kilter nature. Their description was of a man who was at best out of touch and at worst possibly unhinged, speaking about random trivialities. "He didn't look anyone in the eyes," one student recalled. "He was mumbling. When people asked him to speak up, he would boom one word and no more." After talking to them about college football and imploring them to take a tour of the city's monuments and historic sites ("I told them that it was a beautiful city"), he switched gears, trying to connect with the student's anger

over the war, the environment, and racism. "I just wanted to be sure that all of them realized that ending the war and cleaning up the city streets and the air and the water was not going to solve the spiritual hunger which all of us have and which of course has been the great mystery of life from the beginning of time."

As dawn approached, Nixon shook hands with the bewildered protestors and left in his limo for the White House. The incident, which made headlines at the time, is made all the more bizarre imagining it taking place under the watchful gaze of Lincoln's statue. Whatever it says about Nixon's mental state at the time, it at the very least showcases the deep divide of culture and ideology that gripped the nation and that came into focus on a warm spring night under the memorial's lights.

On a sharply cold winter day early in 2009, a different president visited the memorial, under very different circumstances. The "We Are One" inaugural celebration for President-elect Barack

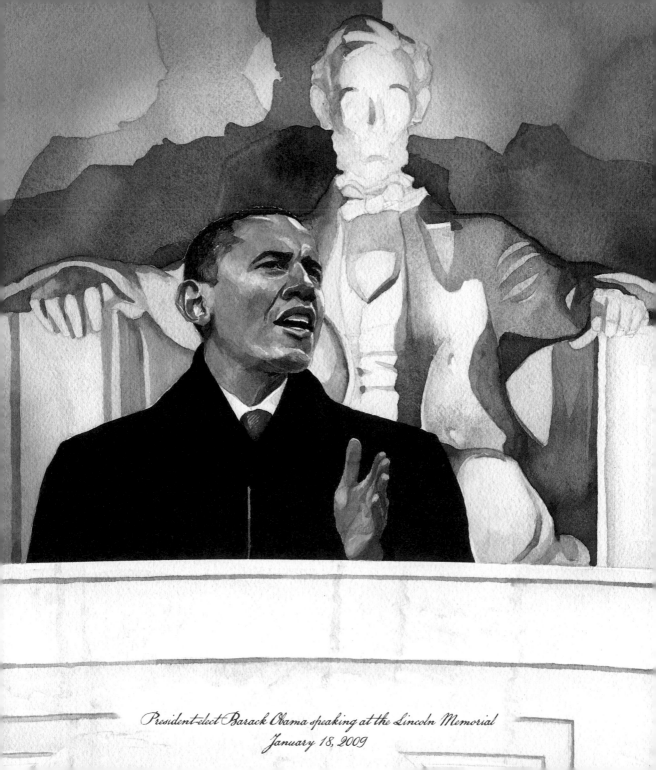

President-elect Barack Obama speaking at the Lincoln Memorial
January 18, 2009

Obama, who would be sworn into office two days later, took place on the steps of the Lincoln Memorial on January 18, 2009. The crowd of 400,000 stretched down the mall to the World War II Memorial to hear the new president-elect speak and to see a variety of performers, from Beyoncé to Bruce Springsteen to legendary folk artist Pete Seeger.

Hawkers throughout the route to the Mall sold everything from unofficial "Obama Air Freshener" bottles to $6 hot dogs to an enthusiastic crowd that was energized by the election of the country's first African American president. The multi-ethnic, all-ages turnout mirrored the international enthusiasm for the new president on both a political and pop-cultural level. As a young student from Sweden in the crowd remarked, "He hasn't done anything yet, but today we get Barack and Denzel together. Hot."

Framed by Daniel Chester French's famous statue of Lincoln, it was clear that the setting, so cemented in the cultural imagination of the world, held a deep ideological sway over the event. It was a power Obama noted in his speech that day. "And behind me, watching over the Union he saved, sits the man who in so many ways made this day possible. And yet, as I stand here tonight, what gives me the greatest hope of all is not the stone and marble that surrounds us today, but what fills the spaces in between. It is you—Americans of every race and region and station who came here because you believe in what this country can be."

OLD ABE IN THE MOONLIGHT

. . .

The ubiquity of the Lincoln Memorial and the "Monumental Core" (as the Mall and its environs are now frequently called) in films and television programs gives the impression that Washington's residents continually meet on the steps of the memorial or at the foot of the Reflecting Pool to engage in everyday conversation or late-night soul searching. One TV location manager sites the instant recognition of such spaces for their constant appearance in pop culture. "If you come to D.C. from L.A., you're coming to D.C. because you want to say, 'Hey we shot in D.C., and here's the proof.'"

With the advent of digital technology, and ever-increasingly restrictive filming rules, many such scenes are digital pastiches, filmed on a sound stage far away. Even for the average tourist, photographing the Lincoln Memorial can be difficult. No filming or photography is permitted "above the white marble steps and the interior chamber of the Lincoln Memorial."

Perhaps the most classic cinematic moment for the Lincoln Memorial is in Frank Capra's 1929 film, *Mr. Smith Goes to Washington*, which features the memorial in two key scenes, the most famous being Jimmy Stewart's late-night visit to the monument, in which he's convinced to continue his fight against graft in the Senate. Ronald Reagan counted the film among his favorites, proclaiming that "When Jimmy Stewart . . . stood in awe of that great man at the Lincoln Memorial, I bowed my head too." The scene is so familiar that its been parodied and recreated numerous

Jimmy Stewart in "Mr. Smith Goes To Washington"

times, including in an episode of *The Simpsons* with Lisa Simpson in the Jimmy Stewart role.

From high to low, the memorial is cultural shorthand for both American ideals and 1960s radicalism. From Forrest Gump's *Zelig*-like insertion into anti-war rallies on the steps of the memorial, to the villainous Decepticon robots discarding the Lincoln statue

and claiming it as a throne in one of the *Transformers* films and its 1980s cartoon counterpart, to the comedy *Night at the Museum* film franchise, in which the Lincoln statue comes to life to help the film's heroes, the memorial's place in the culture is assured even as it is parodied.

Some other notable Lincoln Memorial moments from pop culture include

1951's classic sci-fi film *The Day the Earth Stood Still,* in which the alien Klaatu visits the Lincoln Memorial with his child guide, Bobby. A less-cheery science fiction tableau is in Tim Burton's remake of *The Planet of the Apes*, in which the hero astronaut seemingly returns to Earth, crashing into Washington, D.C., only to look upon a statue of an ape, instead of one of Lincoln, seated on the memorial throne. There are countless "on the steps" moments in films, as characters relay plot points or exposition with a historic backdrop: Clint Eastwood and Rene Russo in *In the Line of Fire*, comic book mutants Professor X and Magneto in *X-Men: First Class*, and Nicholas Cage in *National Treasure*, among many more.

As the memorial grew into legend, so, too, did legend grow up around it. Rumor persists that within the curls of hair on the back of the Lincoln statue, viewers can see the visage of Confederate General Robert E. Lee. No such carving exists intentionally. Another myth regards the statue's hands, which

Lincoln's hands do not spell out his initials in sign language

some believe are arranged to spell out the initials "AL" in American Sign Language (there was no such intention). Or that the fifty-seven steps that lead up to the memorial equal the age of Lincoln at his death—alas, Lincoln was killed at fifty-six years of age. There is also a persistent belief that there is a misspelled word in the Second Inaugural Address. No, there

is not. Although a word was misspelled in the initial carving, it was fixed well before the memorial was dedicated.

What is truly interesting about the memorial is that its symbolic power persists in the face of its familiarity. Whether it's utilized as a call to action or a call for reflection, we cannot help but be moved by the simple fact of its existence and the simple power of the words inscribed on its walls. To conclude this little survey of a big place that is actually bigger than its surroundings, we can all recall those lofty words of Lincoln's, or we can visit a lesser-known poem by the great Langston Hughes, who sums up the power of a monument that asks us to remember the freedom and equality of all people.

Let's go see old Abe
Sitting in the marble and the moon-
light,
Sitting lonely in the marble and the
moonlight
Quiet for ten thousand centuries, old
Abe.
Quiet for a million, million years.
Quiet—
And yet a voice forever
Against the
Timeless walls
Of time—
Old Abe.

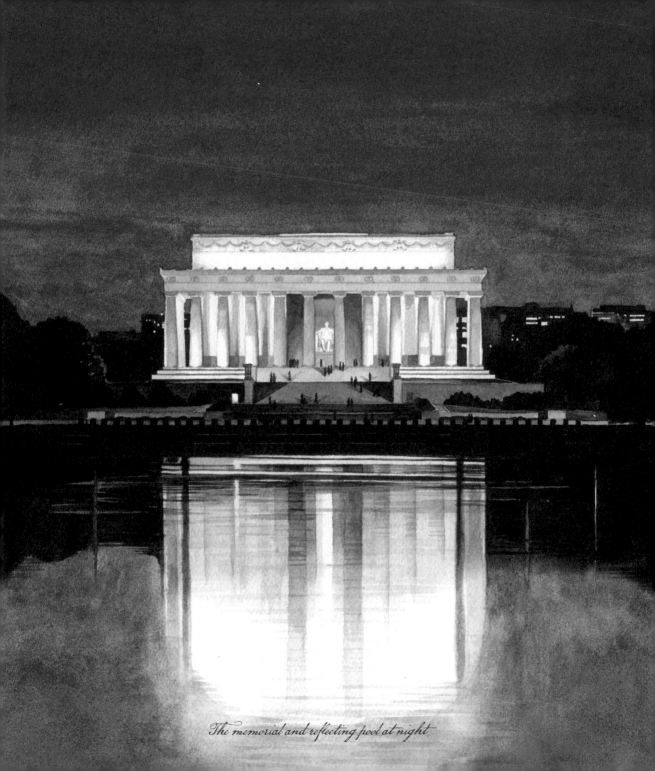

The memorial and reflecting pool at night

THE GETTYSBURG ADDRESS

Thursday, November 19, 1863

. . .

Four score and seven years ago our fathers brought forth on this continent, a new nation, conceived in Liberty, and dedicated to the proposition that all men are created equal.

Now we are engaged in a great civil war, testing whether that nation, or any nation so conceived and so dedicated, can long endure. We are met on a great battlefield of that war. We have come to dedicate a portion of that field, as a final resting place for those who here gave their lives that that nation might live. It is altogether fitting and proper that we should do this.

But, in a larger sense, we can not dedicate—we can not consecrate—we can not hallow—this ground. The brave men, living and dead, who struggled here, have consecrated it, far above our poor power to add or detract. The world will little note, nor long remember what we say here, but it can never forget what they did here. It is for us the living, rather, to be dedicated here to the unfinished work which they who fought here have thus far so nobly advanced. It is rather for us to be here dedicated to the great task remaining before us—that from these honored dead we take increased devotion to that cause for which they gave the last full measure of devotion—that we here highly resolve that these dead shall not have died in vain—that this nation, under God, shall have a new birth of freedom—and that government of the people, by the people, for the people, shall not perish from the earth.

PRESIDENT ABRAHAM LINCOLN'S SECOND INAUGURAL ADDRESS

Saturday, March 4, 1865

. . .

Fellow Countrymen:

At this second appearing to take the oath of the Presidential office, there is less occasion for an extended address than there was at the first. Then a statement, somewhat in detail, of a course to be pursued, seemed fitting and proper. Now, at the expiration of four years, during which public declarations have been constantly called forth on every point and phase of the great contest which still absorbs the attention and engrosses the energies of the nation, little that is new could be presented. The progress of our arms, upon which all else chiefly depends, is as well known to the public as to myself; and it is, I trust, reasonably satisfactory and encouraging to all. With high hope for the future, no prediction in regard to it is ventured.

On the occasion corresponding to this four years ago, all thoughts were anxiously directed to an impending civil-war. All dreaded it—all sought to avert it. While the inaugural address was being delivered from this place, devoted altogether to *saving* the Union without war, insurgent agents were in the city seeking to *destroy* it without war—seeking to dissolve the Union and divide effects by negotiation. Both parties deprecated war; but one of them would make war rather than let the nation survive; and the other would *accept* war rather than let it perish. And the war came.

One-eighth of the whole population were colored slaves, not distributed generally over the Union, but localized in the Southern part of it. These slaves constituted a peculiar and powerful interest. All knew that this interest was, somehow, the cause of the war. To strengthen, perpetuate, and extend this interest was the object for which the insurgents would rend the Union even by war; while the government claimed no right to do more than to restrict the territorial enlargement of it. Neither party expected for the war, the magnitude, or the duration, which it has already attained. Neither anticipated that the *cause* of the conflict might cease with or even before the conflict itself should cease. Each looked for an easier triumph, and a result less fundamental and astounding. Both read the same Bible and pray to the same God; and each invokes His aid against the other. It may seem strange that any men should dare to ask a just God's assistance in wringing their bread from the sweat of other men's faces; but let us judge not, that we be not judged. The prayers of both could not be answered; that of neither has been answered fully. The Almighty has His own purposes. "Woe unto the world because of offenses: for it must needs be that offenses come; but woe to that man by whom the offense cometh!" If we shall suppose that American Slavery is one of those offenses which, in the providence of God, must needs come, but which, having continued through His appointed time, He now wills to remove, and that He gives to both North and South this terrible war, as the woe due to those by whom the offense came, shall we discern therein any departure from those divine attributes which the believers in a living God always ascribe to Him? Fondly do we hope— fervently do we pray—that this mighty scourge of war may speedily pass away. Yet, if God wills that it continue until all the wealth piled by the bond-man's two hundred and fifty years of unrequited toil shall be sunk, and until every drop of blood drawn with the lash, shall be paid by another drawn with the sword, as was said three thousand years ago, so still it must be said "the judgments of the Lord are true and righteous altogether."

With malice toward none, with charity for all; with firmness in the right, as God gives us to see the right, let us strive on to finish the work we are in, to bind up the nation's wounds; to care for him who shall have borne the battle, and for his widow, and his orphan—to do all which may achieve and cherish a just, and lasting peace, among ourselves, and with all nations.

TIMELINE

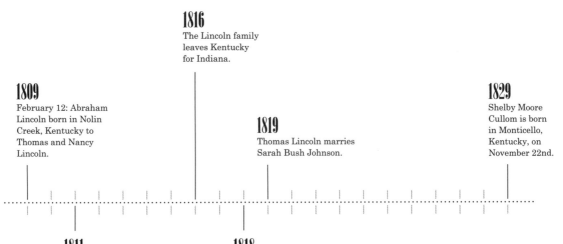

1816
The Lincoln family
leaves Kentucky
for Indiana.

1809
February 12: Abraham
Lincoln born in Nolin
Creek, Kentucky to
Thomas and Nancy
Lincoln.

1819
Thomas Lincoln marries
Sarah Bush Johnson.

1829
Shelby Moore
Cullom is born
in Monticello,
Kentucky, on
November 22nd.

1811
The Lincoln family moves
to a 230-acre farm on Knob
Creek, outside of Hodgeville,
Kentucky.

1818
Lincoln's mother,
Nancy, dies.

1831
Lincoln begins works as a clerk in a store in New Salem, Illinois.

1837
Lincoln moves to Springfield, Illinois to become a junior partner in a law firm.

1846
Lincoln's second son, Edward Baker Lincoln, is born on March 10th.

In August, Lincoln wins a seat on the House of Representatives.

The architect Daniel H. Burnham is born in Henderson, New York on September 4th.

1833
Lincoln partners with William Greene to purchase a store in New Salem. He is also appointed Postmaster of the town.

1840
Lincoln argues his first case before the Illinois Supreme Court

1834
Second bid for Illinois state legislature. This time, Lincoln wins and will serve four consecutive two year terms.

1842
Lincoln marries Mary Todd.

1848
Construction of the Washington Monument begins.

1830
The Lincoln family moves to Illinois, to a homestead ten miles southwest of Decatur.

1836
Lincoln is licensed to practice law.

Joseph Gurney Cannon is born on May 7th in Guilford County, North Carolina.

1843
Robert Todd Lincoln is born on August 1st.

1850
After a two-month illness, Edward Lincoln dies on February 1st.

Daniel Chester French, sculptor of the Lincoln Memorial, is born in Exeter, New Hampshire, April 20th.

Lincoln's third son, William Wallace, is born on December 21st.

1841
Sculptor Augustus Saint-Gaudens is born in Dublin, Ireland, March 1st.

1832
Lincoln runs for state legislature in March.

In April, Lincoln enlists to fight in the Black Hawk War on the western frontier. He is elected captain of the 31st regiment, Illinois Militia. He serves in various capacities until he is mustered out in July.

In August, Lincoln is defeated in his state legislature bid.

1854

Lincoln is elected to state legislature. He resigns to run for the Senate but does not win.

Construction on the Washington Monument halts until 1877.

1861

Alabama, Florida, Georgia, Louisiana, Mississippi, and Texas secede from the Union. Arkansas, Tennessee, North Carolina, and Virginia would soon follow. Jefferson Davies is elected President of the Confederate States of America.

Lincoln delivers his first Inaugural Address, March 4th. In April, Fort Sumter in Charleston, South Carolina, is attacked by the Confederacy; the Civil War begins.

The First Battle of Bull Run, July 21st.

1864

Lincoln appoints Ulysses S. Grant the commander of the Union Army, March 9th.

General William Tecumseh Sherman captures Atlanta, July 22nd.

Lincoln is reelected president, November 8th.

1851

Lincoln's father, Thomas, dies on January 17th.

1857

Lincoln speaks against the Dred Scott decision, an important issue for abolitionists.

1856

Lincoln joins the recently formed Republican Party.

1860

In April, the "Volk life Mask" of Lincoln's face is cast in Chicago, Illinois by Leonard Volk.

Lincoln runs for President as the Republican nominee; he wins. South Carolina secedes from the Union.

1863

Lincoln issues the Emancipation Proclamation on January 1st.

The Battle of Chancellorsville, early May.

The Battle of Gettysburg and the Battle of Vicksburg, early July.

Lincoln delivers the Gettysburg Address, November 19th.

1853

Thomas (Tad) Lincoln is born on April 4th.

1858

During his run for Senate, Lincoln challenges his opponent, Stephen A. Douglas to a series of debates throughout the year, the now-famous Lincoln Douglas Debates, which plunged Lincoln into the national spotlight. Lincoln loses the election.

1862

William Wallace (Willie) Lincoln dies on February 20th.

Lincoln signs the Homestead Act on May 20th.

The Second Battle of Bull Run, August 30th.

1865

Lincoln delivers his Second Inaugural Address, March 4th.

General Robert E. Lee surrenders to Ulysses S. Grant on April 9th.

Lincoln is shot by John Wilkes Booth at the Ford's Theater, Washington D.C., April 14th.

Lincoln dies at 7:22 AM on the morning of April 15th.

While being pursued, John Wilkes Booth is shot and killed, April 26th.

Lincoln is buried in Oak Ridge Cemetery in Springfield, Illinois, May 4th.

1887

August Saint-Gauden's statue, *Abraham Lincoln: The Man* (otherwise known as "The Standing Lincoln") is completed and unveiled in Chicago's Lincoln Park.

1866

Henry Bacon, architect of the Lincoln Memorial, is born in Wateska, Illinois, November 28th.

1884

The Washington Monument is completed.

1867

The Lincoln Monument Commission is established by an act of Congress on March 30th. Preliminary plans for a monument were created by Clarke Mills, but were never enacted.

1871

Tad Lincoln falls ill and dies, July 15th.

1882

Landfill operations begin along the western banks of the Potomac River, they will continue throughout the decade, eventually creating the Potomac Flats and West Potomac Park.

Mary Todd Lincoln dies on July 16th, aged 63.

1888

Master marble carvers the Picirilli family immigrate to New York City from Tuscany, Italy and open a carving business in the South Bronx.

1901

The Senate Park Commission (informally called the "McMillian Commission") is created by the Senate to formalize plans for the betterment of Washington D.C.'s parkland, March 8th. Its members include Daniel H. Burnham and Augustus Saint-Gaudens.

1909

In March, Speaker Cannon, a staunch opponent of the Lincoln Memorial, is stripped of much his power by fellow Republicans.

After passing through both houses of Congress, the bill establishing the Commission of Fine Arts is signed by President William Howard Taft in late May.

1893

The Columbian World Exposition is held in Chicago, Illinois. Both Henry Bacon and Daniel Chester French contribute important work to "The White City."

1903

Long-standing Illinois representative, Joseph "Uncle Joe" Cannon, is elected Speaker of the U.S. House of Representatives.

1913

Henry Bacon's plans for the memorial are approved by the Lincoln Memorial Commission, February 1st.

1898

Henry Bacon designs Daniel Chester French's sculpting studio and country home, "Chesterwood" in rural Massachusetts. It was the first of more than fifty collaborations between the two artists.

1907

Augustus Saint-Gaudens dies in Cornish, New Hampshire on August 3rd, aged 59.

1911

On advisement from the Commission of Fine Arts, the Lincoln Memorial Commission is established on February 9th.

1912

Daniel H. Burnham dies in Heidelberg, Germany on June 1st, aged 65.

Daniel Chester French's "standing Lincoln" statue (with architectural elements by Henry Bacon) is unveiled on the grounds of the Lincoln State Capitol, Lincoln, Nebraska.

1902

The McMillian Plan is published, January 15th. Among other goals, it calls for the development of the National Mall, with a monument to Abraham Lincoln at its western axis.

Senator Shelby Cullom's bill (his second attempt) to "secure plans and designs for a monument to the memory of Abraham Lincoln" is signed by President Theodore Roosevelt on June 28th.

1916

Work on the superstructure and surrounding landfill continues.

French completes a 3-foot clay model of the Lincoln Memorial statue in March.

Over the summer, French completes a 7-foot model of the statue.

1917

A further-refined, 10-foot model of the statue is completed by French in the spring. After viewing the model on site, French and Bacon both agree that the final statue will need to be enlarged to a height of 19 feet.

Landscaping of the terraces and other exterior refinements are put on hold due to World War I.

The superstructure of the building is completed, October 26th.

1923

The grounds of the Memorial are planted with shrubs and trees.

The Reflecting Pool is completed.

1914

Shelby Cullom dies in Washington D.C., aged 85, January 28th.

Ground is broken at the northeast corner of the memorial site, February 14th.

1920

Throughout the late half of 1919 and the early half of 1920, the statue and its pedestal are placed into position in the Memorial.

New architectural underpinnings are added to the terrace walls to stop an undue amount of settlement and slippage.

1924

Henry Bacon dies in New York City on February 17th, aged 57.

1915

The ceremonial laying of the Memorial's cornerstone is held, Feburary 15th.

Work upon the superstructure of the memorial is begun, February 19th.

The foundation for the memorial is completed by April.

In the spring, Daniel Chester French begins initial sketches for the Lincoln Memorial statue.

The three step courses surrounding the building are completed, June 30th.

1919

In the Bronx, New York, The Piccirilli brothers carve the statue based on French's design. It is composed of 28 marble blocks.

1922

The Lincoln Memorial dedication ceremony, May 30th.

Work begins on the Reflecting Pool, summer and fall of 1922.

1918

The terraces and approaches are completed throughout this year and into 1919.

The interior paintings by Jules Guernin were completed and placed into the memorial throughout 1918 and 1919.

1921

Throughout 1920 and 1921, final landscaping elements are completed, including the creation of the circular roadway that encompasses the memorial.

1926

Robert Todd Lincoln dies in Manchester, Vermont, aged 82, July 26th.

Joseph Cannon dies in Danville, Illinois, aged 90, Nov 26th.

1929

Martin Luther King, Jr. born in Atlanta, Georgia on January 15th.

Mr. Smith Goes to Washington released.

1941

The Negro March on Washington to protest discrimination in the defense industry and armed services is organized by A. Philip Randolph and others. The march is cancelled after its organizers meet with President Roosevelt.

FDR signs Executive Order 8802 on June 25th, the first people of equal opportunity legislation in American history.

1931

Daniel Chester French dies in Stockbridge, Massachusetts, on October 7th, aged 81.

1951

The Day the Earth Stood Still released.

1968

Martin Luther King, Jr. is assassinated in Memphis, Tennessee, on April 4th.

1939

Marian Anderson sings on the steps of the Memorial, Easter Sunday, April 9th.

1970

President Richard Nixon visits student protestors at the Lincoln Memorial in the pre-dawn hours of May 9th.

1963

The March on Washington for Jobs and Freedom is held, August 28th.

President Kennedy is assassinated in Dallas, Texas, on November 23rd.

2011

Transformers: Dark of the Moon released.

X-Men: First Class released.

1994

Forrest Gump released.

1999

The Simpsons parodies *Mr. Smith Goes to Washington.*

2013

President Obama, President Clinton, and President Carter honor the 50th anniversary of the March on Washington in a commemorative ceremony at the Lincoln Memorial on August 28th.

1983

A march is held in honor of the 20th Anniversary of the March on Washington for Jobs and Freedom, August 27th.

2004

National Treasure released.

1993

In the Line of Fire released.

2009

We Are One, the inaugural celebration of President Barack Obama is held on the steps of the memorial, January 18th.

The Lincoln Memorial Rededication Ceremony, May 30th, exactly four score and seven years from the date of its initial dedication.

Night at the Museum: Battle of the Smithsonian released.

2001

Planet of the Apes released.

BIBLIOGRAPHY AND
FURTHER READING

Barber, Lucy G. *Marching On Washington: The Forging of an American Political Tradition*. Berkeley and Los Angeles: University of California Press, 2002.

Broderick, Mosette. *Triumvirate: McKim, Mead & White: Art, Architecture, Scandal, and Class in America's Gilded Age*. New York: A. A. Knopf, 2010.

Cocklin, Edward F. *The Lincoln Memorial in Washington*. Washington, DC: United States Government Printing Office, 1927.

Gilbert, Ben W., and the staff of the *Washington Post*. *Ten Blocks from the White House: Anatomy of the Washington Riots of 1968*. New York: Frederick A. Praeger, 1968.

Gutheim, Frederick, and Antoinette J. Lee. *Worthy of the Nation: Washington D.C., from L'Enfant to the National Capitol Planning Commission*. Baltimore: Johns Hopkins University Press, 2006.

Hines, Thomas S. *Burnham of Chicago: Architect and Planner*. Chicago: University of Chicago Press, 2008.

Jacob, Kathryn Allamong. *Testament to Union: Civil War Monuments in Washington*. Baltimore: Johns Hopkins University Press, 1998.

Larson, Erik. *The Devil in the White City: Murder, Magic, and Madness at the Fair that Changed America*. New York: Crown Publishers, 2003.

Lewis, David L. *District of Columbia: A History*. New York: W. W. Norton, 1976.

Mandel, Susan. "The Lincoln Conspirator." *Washington Post*, February 3, 2011.
McNichol, Tom. (November 14, 2011) "I Am Not a Kook: Richard Nixon's Bizarre Visit to the Lincoln Memorial." Accessed at TheAtlantic.com, http://www.theatlantic.com/politics/archive/2011/11/i-am-not-a-kook-richard-nixons-bizarre-visit-to-the-lincoln-memorial/248443/, February, 2013.

Moore, Charles. *Daniel H. Burnham, Architect, Planner of Cities.* New York: Houghton Mifflin, 1921.

Peatross, C. Ford, ed. *Capital Drawings: Architectural Designs for Washington, D.C., from the Library of Congress.* Baltimore: Johns Hopkins University Press, 2006.

Peterson, Merrill D. *Lincoln in American Memory.* New York: Oxford University Press, 1994.

Richman, Michael. *Daniel Chester French: An American Sculptor.* New York: The Preservation Press, 1976.

Robinson, Charles Mulford. *Modern Civic Art: Or, The City Made Beautiful.* New York and London: G. P. Putnam's Sons, 1918.

Stewart, George R. *Names On the Land: A Historical Account of Place Naming in the United States.* New York: Random House, 1945, reprinted by the *New York Review of Books*, 2008.

Thomas, Christopher A. *The Lincoln Memorial and American Life,* Princeton, NJ: Princeton University Press, 2002.

INDEX

JAY SACHER is a writer, editor, and illustrator, and the author of several books, including *How to Hang a Picture and Other Essential Lessons for the Stylish Home, How to Swear Around the World*, and *A Compendium of Collective Nouns*. His work has been published in *The Bay Citizen, Meathaus Comics*, and *The Classical*, among others. He lives in Brooklyn, New York.

. . .

CHAD GOWEY is a professional illustrator whose work has been featured in numerous publications such as Euroman, Songlines, and Bookmarks. He is a graduate of the Rhode Island School of Design and lives in Boston, Massachusetts.

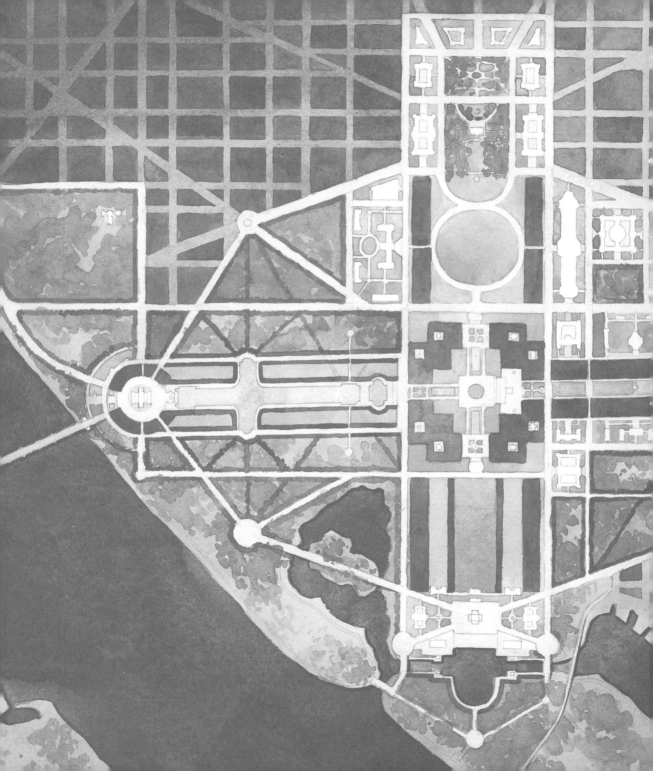